SCIENCE IN ART

Works in the National Gallery that illustrate the history of science and technology

BSHS MONOGRAPHS

Series Editor: Dr J. F. M. Clark, University of Kent at Canterbury

For titles 1 - 5 the series editor was Dr Roger Smith, University of Lancaster; for titles 6 and 7 the series editor was Dr R. G. Smith, University of Leicester; for titles 8 - 10 and the second edition of 4, the series editor was Dr P. J. Weindling, University of Oxford. Dr Weindling was also responsible for initiating the second edition of 1.

SCIENCE IN ART

Works in the National Gallery that illustrate the history of science and technology

by

J. V. Field

and

Frank A. J. L. James

British Society for the History of Science

1997

Published by the British Society for the History of Science,
31 High Street, Stanford in the Vale, Faringdon,
Oxfordshire, SN7 8LH, England

First published 1997

Printed and bound in England, AB Print & Design Ltd, London

ISBN 0-906450-13-6

Contents

LOCATIONS OF PICTURES HAVE BEEN SUPPLIED ON A SEPARATE SHEET

Notes

1. Since the National Gallery sometimes finds it necessary to move pictures, locations have been given on a separate sheet. Locations are listed according to artist, and the work concerned is identified by its inventory number.

 The current location of a particular work can be found by using the computers in the Micro Gallery.

2. Pictures are sometimes known by more than one title. We have in general given the title as found in the National Gallery's printed catalogue.

Preface

The National Gallery collects pictures for their interest as works of art, with regard to their intrinsic quality and to their historical significance. A fully comprehensive guide to its collections — if such a thing were to be conceived — and with no restriction placed upon the length of text, would largely be concerned with art and its history. It might also contribute to other areas of history, such as the history of musical instruments or armour, since many of the Gallery's earlier pictures show angels with musical instruments (portrayed in various degrees of detail) or saints and donors in armour. Though their contribution may in certain circumstances be a considerable one, contemporary pictures do not provide our only evidence for such forms of history. For instance, actual musical instruments and armour of many dates are to be found in museum collections throughout the world, and detailed information about their design and manufacture can be found in contemporary books.

The present brief guide to the National Gallery's collections is not intended as a substitute for the Gallery's own range of catalogues of its collections (available in printed form, on computer screen access in the Micro Gallery, and on CD ROM). This book provides a historical supplement to these catalogues, and can also be used independently of them. Our work is chiefly concerned with things that cannot, or at any rate do not, survive in large quantity in museums, things such as scientific ideas, or the everyday objects that were usually thrown away or (if made of metal) melted down so that their metal could be re-used. We are writing as historians of science and technology who see the Gallery's collections as providing an essentially accidental, but none the less interesting, series of illustrations of the science and technology of the past. We hope to encourage specialist historians and teachers (at all levels) to make more use of such illustrations in their research and teaching, and in their publications. We also hope that visitors to the National Gallery may find that our book widens the context in which they see certain pictures and thus deepens their understanding and enjoyment of them as works of art.

We are grateful to the following for help with various of the entries in this book: Dr F. Ames-Lewis (Birkbeck), C. N. Brown (Science Museum, London), Dr S. Foister (National Gallery), Dr W. D. Hackmann (Museum of the History of Science, Oxford), Dr N. Jachec (Birkbeck), J. H. Leopold (British Museum), Professor W. Vaughan (Birkbeck), M. T. Wright (Science Museum, London).

<div align="right">

J .V. F.
Department of History of Art, Birkbeck College, University of London

F. A. J. L. J.
Royal Institution Centre for the History of Science and Technology

October 1996

</div>

Introduction

Historians of science and technology rely to a very great extent upon texts. Though monumentally large items such as bridges and aqueducts fare rather better, it is extremely rare for a historically important machine or piece of scientific apparatus to survive in a condition that allows one to use it as a source of information. One of the telescopes made by Galileo Galilei (1564 - 1642) is, indeed, preserved in the Museum of the History of Science in Florence, but it has the status rather of a holy relic than of a piece of historical evidence, since nearly four hundred years have had a serious effect upon the optical properties of its lenses. Luckily, Galileo's books tell us what he saw. One may doubt the veracity of his account, but reference to the actual telescope is hardly likely to settle the matter. On the other hand, surviving apparatus used by Michael Faraday (1791 - 1867) has proved to be revealing of his experimental methods; and the actual models of the DNA molecule made by James Watson (b.1928) and Francis Crick (b. 1916), who won a Nobel prize for their work in 1962, are similarly helpful as a guide to the way they were thinking about their problems. Moreover, the story is rather different if one is considering a historical question less centred on a particular individual. For instance, the small brass telescopes that survive in quantity from the second half of the eighteenth century are tangible evidence for the vogue for comet-hunting associated with the successful prediction of the return of Halley's Comet in 1758. Similarly, we know that globes, usually in pairs, one terrestrial and one celestial, were deemed suitable for a gentleman's study, and it is welcome confirmation to find just such a pair of globes shown in the portrait of Constantijn Huygens (1596 - 1687), the father of the famous mathematician and natural philosopher Christiaan Huygens (1629 - 1693) (portrait by Thomas de Keyser (1596/7 - 1667), NG 212, see below under 'Pictures of or by persons with 'scientific' connections', entry 1.2). The elder Huygens also had a serious interest in natural philosophy, and in music. He was a competent composer as well as a lover of music. The inclusion of the globes in his portrait is clearly meant to indicate that he is a learned man. In referring to the nature of Huygens's learning, and elsewhere in this book, we have used the period term 'Natural Philosophy', and avoided the modern word 'Science'. We have done so because the terms are not equivalent. Natural philosophy was the complete study of natural things, shading off into Philosophy proper and into Theology. The use of the term 'Science' in its modern sense dates from the nineteenth century, and the word 'scientist', coined in the 1830s, was not widely accepted until about a century later.

Globes and — from the seventeenth century — telescopes were expensive items (perhaps as costly as a motor car would be today), but many of them were made of perishable materials and did not remain very long in a condition good enough to ensure that they eventually ended up in a museum. Unless an object is made of lasting materials and small enough to be lost or put out of the way, the rule for survival is that it should visibly be worth more than its weight as scrap. Many scientific instruments, and ordinary or domestic objects, all but vanish from the archaeological record. Our stock of Tudor wooden tableware — by far the commonest type of its time — was hugely increased by the investigation of the wreck of Mary Rose. (The lower orders, on ships as on shore, ate off wood.) Indeed, since ships themselves were normally destroyed at the end of their useful life, the actual timbers of Mary Rose are also of historical interest. Paintings provide a very important supplement to our knowledge of such ordinary and perishable objects, particularly since they often show them in context. Many examples will be found below, including fire irons (in a picture of the Virgin and Child by an artist in the workshop of Robert Campin (1378/9 - 1444), NG 6514), carpenter's tools (in a picture of St Joseph by Philippe de Champaigne (1602 - 1674), NG 6276) and a wooden doll (in a family portrait attributed to Michiel Nouts (active 1656), NG 1699).

Our list of non-survivors for which we regarded paintings as valuable evidence was eventually divided into several categories: 'Waterwheels', 'Windmills'. 'Domestic and low technology', 'Transport' and 'New technology of the nineteenth century' (of which several Impressionists appear to have been admirers). Pictures showing waterwheels and windmills ought to be far more common than they are, since such mills were the chief sources of energy at the time most of the landscapes in the Gallery were painted. However, mills were mere

human additions to the landscape, of no particular visual interest, and in the earlier period artists seem often to have left them out of their pictures, probably in rather the same spirit that a photographer today might try to take a view that avoided including a line of pylons. This attitude seems, however, to have been less common in the Netherlands. There are, for instance, pictures by Ruisdael which take mills as their subject. In any case, Romantic painters gave more importance to human contributions to landscape. There is accordingly a continuing debate about how far the Impressionists, who worked (they said) directly from nature — 'in the open air' *(plein air)* rather than in a studio — should be seen as making a social comment, or indeed as departing in an important way from the work of, say, Constable.

These technological categories were developed as we made our way round the Gallery. Our scientific categories were largely developed earlier — ideas in pictures being more elusive elements than fire irons. One obvious category was that of pictures which had direct scientific connections: portraits of natural philosophers, physicians and so on. We also found that there were a few pictures showing scientific instruments or scientific activity of some kind, the most spectacular being Joseph Wright's fine picture of a scientific lecturer demonstrating the use of the air pump (NG 725). In tribute to their significance, we put these pictures in a category of their own. In addition, we have considered three categories of pictures that put scientific information or techniques on display in rather different ways. The first such category we have called 'Mirrors'. It is somewhere between what would now be called art and science since we have put into it those pictures that seem to us to show a particular concern with specular reflection, a phenomenon whose mathematical rules had been known since ancient times. The next, more narrowly scientific, category is that of paintings which have a connection with scientific matters, for instance, the use of careful perspective construction (Saenredam's painting of the interior of the Great Church at Haarlem, NG 2531) or the display of a detailed map (in a portrait by Pompeo Batoni (1708 - 1787), NG 6459) or of a rhinoceros (in a genre scene by Pietro Longhi (Pietro Falea, 1702 (?) - 1785), NG 6459), or even the wilful neglect of scientific information (the rendering of the Moon in a picture of the Immaculate Conception by Velázquez (1599 - 1660), NG 6424). Our final scientific category is that of pictures showing meteorological phenomena.

We were chiefly concerned with paintings in the Gallery, but it would have been perverse to omit the floor mosaics by Boris Anrep (1885 - 1969) which form part of the Gallery building itself. However, since they are considerably later in date than most of the works in the Gallery's collections, and since their representations of people and things are inevitably rather schematic, we have included them in a separate category, at the end of our series of lists.

The list of pictures in each category is in date order, and is preceded by a short introduction. The introductions do not pretend to give more than a very cursory account of the relevant parts of history of science and technology. Their chief purpose is to explain where the particular pictures concerned may be considered to fit into this history. Issues of art history have been discussed only when it seemed imperative to do so. The chief instance of such discussion is in the introduction to our section on Domestic and Low Technology. Since our own time is almost fanatical in its devotion to correct historical reconstruction for the settings of works of fiction (at least on film or on television), it seemed as well to look briefly at earlier attitudes before presenting pictures as evidence. Both introductions and entries for specific pictures give references to more detailed scholarly literature where appropriate. We have not given references to general histories or to monographs on particular artists.

As the introductions to each section make clear, most of our lists are not intended to be exhaustive. Some, in particular, we hope may encourage visitors to look more carefully at other pictures (in the National Gallery and elsewhere) to see whether they might perhaps be understood as showing some of the properties that led us to include pictures in one or another of our lists. We do not believe that readers necessarily start by reading Introductions, so — at the inevitable cost of some slight repetitions of information — entries for particular paintings have been made as self-contained as possible.

Pictures which have entries longer than 150 words

Pictures are listed in chronological order.

Giovanni da Milano (active 1346 - 1369(?)), *Virgin, Christ of the Apocalypse and St John,* each panel 90 x 38 cm. NG 579a. Under 'Scientific information', entry 4.1.

Masaccio (Tommaso di Giovanni, 1401 - c.1429), *Madonna and Child with Angels ('The Pisa Madonna'),* 1426, 135.3 x 73 cm. NG 3046. Under 'Scientific information', entry 4.2.

Fra Filippo Lippi (c.1406 - 1469), *Annunciation,* c. 1455, 68.6 x 152.4 cm. NG 666. Under 'Scientific information', entry 4.5.

Pinturicchio (Bernardino di Piero, c.1454 - 1513), *Penelope and the Suitors,* c.1509, 125.5 x 152 cm. NG 911. Under 'Domestic and low technology', entry 8.5.

Jan Gossaert (also called Mabuse, c.1478 - 1532), *Portrait of a girl* (possibly Jacqueline de Bourgogne), c. 1522, 38.1 x 28.9 cm. NG 221. Under 'Pictures that include scientific activity or impedimenta', entry 2.1.

Hans Holbein (1497/8 - 1543), *The Ambassadors,* signed and dated 1533 (inscription in perspective on the floor at the left), 207 x 209.5 cm. NG 1314. Under 'Pictures that include scientific activity or impedimenta', entry 2.2.

Thomas de Keyser (1596/7 - 1667), *Portrait of Constantijn Huygens,* signed and dated 1627, 92.4 x 69.3 cm. NG 212. Under 'Pictures of or by persons with "scientific" connections', entry 1.2.

Flemish School, c. 1620, *Cognoscenti with pictures etc.,* 95.9 x 123.5 cm. NG 1287. Under 'Pictures that include scientific activity or impedimenta', entry 2.3.

Diego Velázquez (1599 - 1660), *Immaculate Conception,* about 1618, 135 x 101.6 cm. NG 6424. Under 'Scientific information', entry 4.9.

Diego Velázquez (1599 - 1660), *Rokeby Venus,* probably 1647 - 51, 122.5 x 177 cm. NG 2057. Under 'Mirrors', entry 3.12.

Jan Steen (1626 - 1679), *An Interior of an Inn, 'The Broken Eggs',* probably 1665 - 70, 43.3 x 38.1 cm. NG 5637. Under 'Domestic and low technology', entry 8.16.

Francesco Guardi (1712 - 1793), *Venice, the Arsenal,* 1755 - 60, 62.3 x 96.9 cm. NG 3538. Under 'Transport', entry 9.18.

Joseph Wright of Derby (1734 -1797), *The Air Pump,* oil on canvas, signed and dated 1768, 182.9 x 243.9 cm. NG 725. Under 'Pictures that include scientific activity or impedimenta', entry 2.6.

J. M. W. Turner (1775 - 1851), *The Fighting Temeraire,* dated 1838, 90.8 x 121.9 cm. NG 524. Under 'New technology of the nineteenth century', entry 10.1.

Camille Pissarro (1830 - 1903), *Boulevard Montparnasse,* 1897, 53.3 x 64.8 cm. NG 4119. Under 'New technology of the nineteenth century', entry 10.5.

1. Pictures of or by persons with 'scientific' connections

This section includes portraits of people connected with natural philosophy, mathematics or medicine. It should be remembered that on the whole it was only royalty, the nobility or the well-to-do who had their portraits painted. However, scholars would sometimes have a small portrait done to send to friends whom they knew through correspondence rather than in person; and from the seventeenth century onwards learned academies commonly collected portraits of notable people whose work they admired. Engraved copies of such portraits may appear as frontispieces to books. Their status as good likenesses of the authors concerned is usually doubtful. The National Gallery's portraits of people with 'scientific' connections were chosen for their quality as works of art, and are all of the kind intended for relatively private display, say in a sitting room.

We have also included a picture by Laurent de la Hyre (1606 - 1656), an artist who himself took an interest in the mathematics of his day, and a seventeenth-century Italian picture of a man which may be intended as a fictional representation of the Ancient Greek natural philosopher Democritus of Abdera.

Some additions to this list will be found in Section 11, which considers the floor mosaics by Boris Anrep (1885 - 1969).

1.1 Peter Paul Rubens (1577 - 1640), *Portrait of Thomas Howard (1584 - 1646), Earl of Arundel,* 67 x 54 cm.

The sitter was well known as a collector of works of art. He was the grandfather of Henry Howard (1628 - 1684) who in 1666 presented the family library to the Royal Society, which had been founded in 1660. This gift helped to establish the intellectual standing of the Society.

NG 2968.

1.2 Thomas de Keyser (1596/7 - 1667), *Portrait of Constantijn Huygens,* signed and dated 1627, 92.4 x 69.3 cm.

The sitter, Constantijn Huygens (1596 - 1687), a very rich man who had wide interests in natural philosophy and in music, was the father of the mathematician and natural philosopher Christiaan Huygens (1629 - 1693). There is a pair of globes in the background. No doubt Constantijn Huygens did possess such globes, which resemble known examples made by the famous cartographer Willem Janszoon Blaeu (1571 - 1638). However, their inclusion in his portrait is not only a sign of their importance to him but also an indication of his being a learned man. It is, in fact, not unknown for the same objects to appear repeatedly in portraits by a particular artist. For instance, a fine table clock appears in several portraits by Titian (c.1485 - 1576), none of which is in the National Gallery, and very probably belonged to Titian himself, its appearance in the portraits being merely symbolic. What it symbolised is a problem for historians of art — a problem that is also encountered in interpreting the ostentatiously large number of timekeeping devices found in Holbein's The Ambassadors. See entry 2.2 below.

NG 212. ■ Plate, of whole

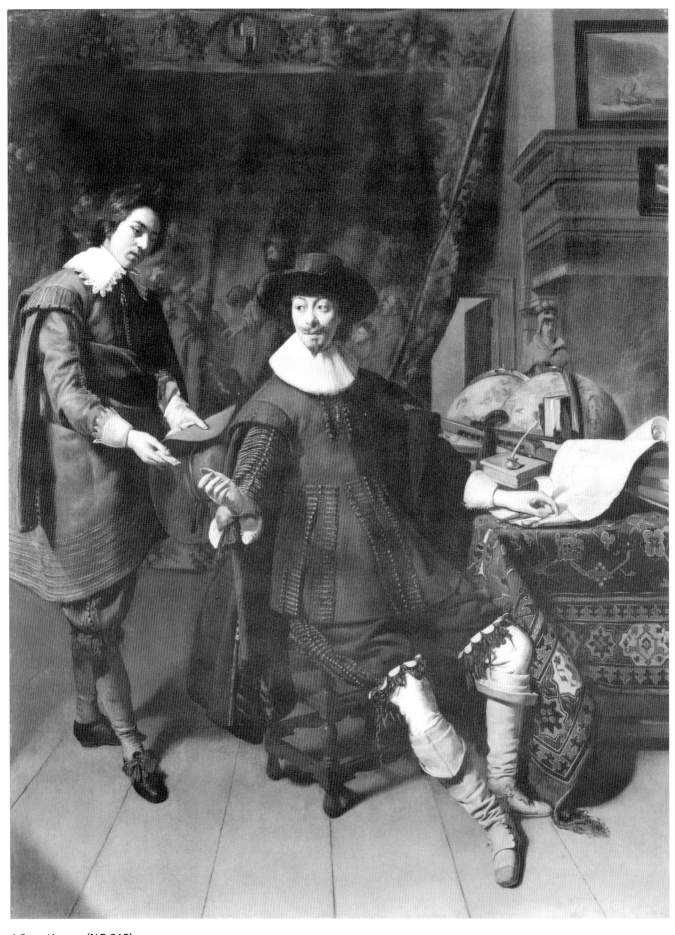

1.2 Keyser (NG 212)

1.3　Laurent de La Hyre (1606 - 1656), *Grammar,* signed and dated 1650, 102.9 x 113 cm.

The artist was the father of the mathematician Philippe de La Hire *(sic)* (1640 - 1718), whose initial training was as a painter. (Variable spelling extended to proper names in the seventeenth century.) Laurent was an advocate of the perspective method of Girard Desargues (1591 - 1665), whose important new geometrical method was employed by Philippe in his work on conic sections.

On perspective, see section 4 below.

References: Field & Gray (1987); Kemp (1990); Field (1997)

NG 6329.

1.4　Italian School, 17th-century, *An Old Man with a Pilgrim-bottle,* 112.4 x 91.4 cm.

This is not a portrait of a known sitter. The man may be intended as the Greek natural philosopher Democritus of Abdera (second half of 5th century BC), the foremost ancient exponent of the theory that all matter was made up of indivisible particles, that is 'atoms'. A very different form of Atomism, which nevertheless determinedly traced its ancestry back to Democritus, became popular in the seventeenth century. Nineteenth-century Atomism, from which today's theories derive, is different again. It was not generally accepted until the late 1890s, when J. J. Thomson (1856 - 1940) discovered the first sub-atomic particle, the electron. See also entry 11.2 below.

NG 5595.

1.5　Thomas Gainsborough (1727 - 1788), *Portrait of Dr Schomberg,* c. 1770, 233 x 153.7 cm.

The sitter was a physician, Ralph Schomberg (1714 - 1792), born in Germany but educated in England, who practised in the fashionable spa town of Bath, where Gainsborough was living at the time this portrait was painted. The sitter is shown merely as a gentleman, without any indication of his profession.

Gainsborough, who was a very successful portrait painter, later moved to London. His social circle included musicians and people employed in 'mechanical' trades, and he had a family connection with the Industrial Revolution: his brother Humphrey (1718 - 1776) practised as an engineer and designed an engine seen by the firm of Boulton and Watt as a potential rival to one designed by Watt. (For steam engines, see Introduction to section 10 below.)

Reference: French, Palmer & Wright (1985)

NG 684.

1.6　J. A. Vallin (1760 - 1835), *Portrait of Dr Forlenze,* 1807, 209.6 x 128.3 cm.

The sitter, Joseph-Nicolas-Blaise Forlenze (1751 (?) - 1833), was educated in Naples and later practised as an oculist in Paris. He is not shown with any instruments or other attributes that might indicate his professional interests. The mountain in the background is Vesuvius, and the lighthouse may be one at Naples.

NG 2288.

2. Pictures that include scientific activity or impedimenta

Some of the pictures in this section might have been included in the previous one. They feature here because the scientific apparatus or activity that they show seems to be of more interest than the identity of the sitter or sitters. It should be noted, however, that none of the pictures concerned shows, or even (with the possible exception of Adriaen van Ostade's picture of the alchemist, NG 846) purports to show, the process of scientific observation or experimentation. The pictures in fact mainly show specialised instruments that embody established scientific ideas and knowledge. On the whole, we do not see the scientific apparatus used in establishing that knowledge. For instance, the small armillary sphere shown by Gossaert (NG 221) could only have been used as a demonstration model for teaching purposes; and the elaborate sundial shown by Holbein (NG 1314) merely embodies astronomical knowledge about the observed movement of the Sun. Moreover, the air pump shown by Wright of Derby (NG 725) is being used simply to demonstrate well known phenomena. All the same, the pump itself is like the one used in the previous century to establish the reality of those phenomena. To do this involved overcoming various technical problems with the apparatus and considerable learned opposition to the interpretation placed upon the experimental results that were obtained. Naturally enough, no trace of these vicissitudes is to be found in Wright's picture.

In fact, a few of the scientific objects shown in the pictures we have included in our list might, in principle, have been used to make discoveries, but the pictures concerned do not show them in that kind of context. In the pictures, the scientific objects are, quite literally, there for show. They are essentially symbolic, and the high quality of their finish is at least partly an indication of that fact.

There are medieval illustrations that show practical apparatus, and similar pictures occur in Renaissance texts, sometimes purporting to show the author's own laboratory. Diagrams of apparatus are, of course, abundant in later scientific texts. However, the social context of such illustrations is very different from that of the paintings listed here. The absence of 'real' scientific activity in pictures in the National Gallery is probably to be explained in rather the same way as the absence of pictures of waterwheels and canals (see sections 6 and 9 below): such subjects were apparently not usually considered suitable adornments for the walls of a living room. As regards scientific activity, by the nineteenth century much of it went on in specialised premises which were not generally accessible. In any case, in scientific practice, a large part is played by ideas, that is current scientific theories. As we remarked in our general introduction, when it comes to paintings, scientific ideas are more difficult to locate than fire irons. We have none the less made some suggestions about them in section 4 below.

A few additions to the present list will be found in Section 11, which considers the floor mosaics by Boris Anrep (1885 - 1969).

2.1 Jan Gossaert (also called Mabuse, c.1478 - 1532), *Portrait of a girl (possibly Jacqueline de Bourgogne)*, c. 1522, 38.1 x 28.9 cm.

The child holds a small armillary sphere, which has elaborate handles and seems to have a loose horizon circle (no such circles are known to survive).

The armillary sphere, which is a model of the Universe, showing the celestial circles that define the path of the Sun, was used as a visual aid in elementary instruction in astronomy. In this case, the Earth is shown in the centre, since at the time it was generally believed that the Earth was at rest in the centre of the Universe (see entry 4.1 below). The inclusion of a small and clearly precious armillary sphere in the portrait

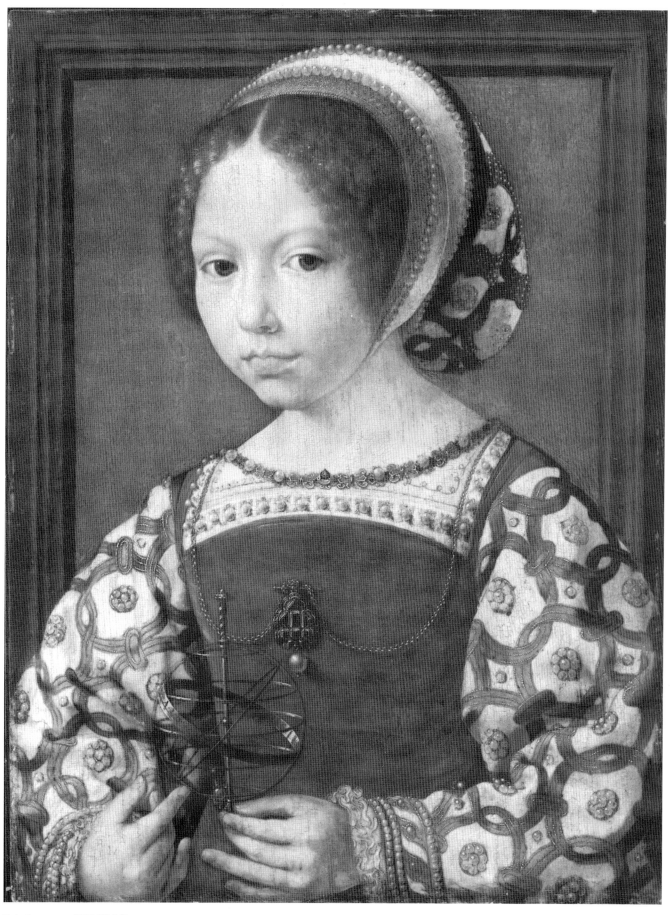

2.1 Gossaert (NG 2211)

may be intended to indicate that the sitter has been provided with a good education in the mathematical sciences, but, given her probable rank, the sphere is more likely to be of astrological significance, perhaps a reference to her having a high destiny of some kind. At this period, astrology, the study of the influence of heavenly bodies upon terrestrial ones (for instance the influence of the Moon on the sea), was regarded as intellectually respectable, though a bit less reliable than astronomy. Its chief use in was in weather forecasting.

It has been claimed in the art historical literature that the armillary sphere is being held 'the wrong way up'. The suggestion seems to be unfounded. Although the armillary sphere appears to be shown in some detail, it is not possible to make out identifications of the constellations along the band that indicates the position of the Zodiac. It is thus not possible to tell whether the instrument is held with the North or the South Celestial Pole uppermost. In any case, the matter is of no importance since, in astronomical terms, the celestial sphere has no 'right' or 'wrong' way up.

NG 2211. ■ Plate, of whole

2.2 Hans Holbein (1497/8 - 1543), *The Ambassadors,* signed and dated 1533 (inscription in perspective on the floor at the left), 207 x 209.5 cm.

The sitters are Jean de Dinteville (left), who commissioned the picture, and Georges de Selve. The former was French ambassador to England in 1533, the latter was Bishop of Lavaur. They are shown with an ostentatiously large number of devices associated with the measurement of time, some of them of relatively modern design, though none of them is shown exactly as it would be used. This departure from adjustment may be deliberate: it is perhaps intended as a symbol of the instability of the world and thus a reminder of mortality. We cannot attempt here to offer an explanation of the picture as a whole. However, fulfilling our more modest purpose, of identifying the scientific apparatus shown behind the sitters, does tend to suggest that the picture is a good example of the interest taken by the upper classes in the mathematical sciences: Geometry, Astronomy, Arithmetic and Music. There seem to be allusions to all four in this picture. Moreover, the inclusion of a 'practical' text on arithmetic (on the lower shelf) is witness to the spread of this kind of mathematical education among the upper classes. The rise in social status of what had begun as, essentially, elementary mathematics for tradesmen and artisans, is of historical importance for the technical development of mathematics because it is in texts of 'practical' or 'commercial' arithmetic that we find the beginnings of algebra in Western Europe.

(a) On the upper of the two shelves behind the figures there are, from the left,

(a1) A celestial globe, in a fairly elaborate mounting that includes graduated circles. The strip running at about 45° to the horizontal is an adjustable semicircle used to set up the astrological houses. Such semicircles were detachable, and none is known to survive. The overall colour of the globe is blue, and bright stars are picked out in gold. Not all the constellations are exactly the same as those in use today. One star name, on the part of the globe facing most directly towards the spectator, appears to be a mistake. We have a star called 'Galacia'. This may be Holbein's misreading of a word intended to indicate that the area concerned is part of the Milky Way.

(a2) A wooden pillar sundial (rather large) of the type sometimes called a 'Shepherds' dial'. An apparently very similar instrument is shown in Holbein's portrait of the astronomer Nicholas Kratzer (1497 - 1550 ?), painted in 1528 and now in the Louvre. (A good copy of the portrait is in the National Portrait Gallery, London. Kratzer was court astronomer/astrologer to Henry VIII.)

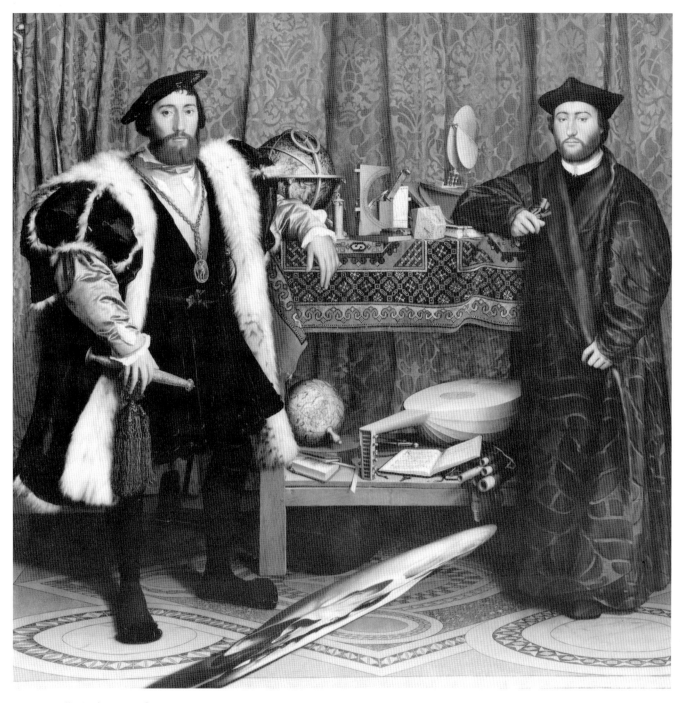

2.2 Holbein (NG 1314)

(a3) Two instruments for measuring altitude: first a wooden vertical semicircle, with a plumb bob and a pivoting ruler fitted with sights and marked with divisions that are indicated as each corresponding to a sign of the Zodiac; and second, behind the semicircle, a horary quadrant, an instrument used to tell the time. A wooden semicircle very like the one shown in this picture is also seen in the portrait of Nicolas Kratzer to which we have already referred. The inclusion of a Zodiac scale on the ruler indicates that the instrument was used for telling the time by measuring the height of the Sun. The quadrant is made of wood, and is either painted white or, more likely, has a piece of paper printed with the appropriate sets of lines and scales pasted to it. Such paper instruments were fairly common in the sixteenth century. Both these instruments are shown in a way that does not correspond to how they are used. In use, the position of the movable ruler would be read against the scale on the outer rim of the semicircle; and the quadrant would be held so that its curved scale was at the bottom, where the position of a plumb line was read off against it.

(a4) A polyhedral sundial that appears to be made of ivory but (given its size) may consist of ivory plates on a wooden carcass. In his portrait of Nicolas Kratzer, Holbein shows the astronomer making an instrument very like this one. The shape of the body of the instrument appears to be that of a regular octahedron with a pair of

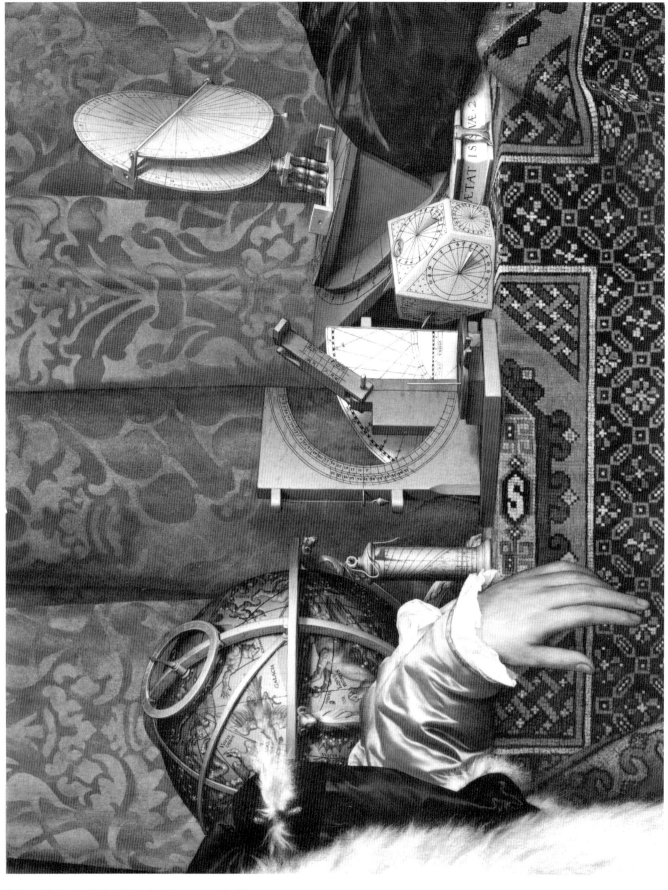

2.2 Holbein (NG 1314, detail, upper shelf)

opposite corners cut off to give two additional, square, faces — making each of the neighbouring faces into an isosceles trapezium in the process. (The regular octahedron has eight equilateral triangle faces, meeting four by four at each corner of the solid. Alternatively, it can be thought of as two pyramids, one constructed on each side of the same square base.) There is a small inset compass to allow the instrument to be set up correctly — which has apparently not been done, since the dials that are visible all indicate different times. The instrument has been designed to stand on one of the trapezoidal faces, making uppermost trapezoidal face, with the compass, horizontal — not as Holbein has shown it. Calculation shows that the uppermost visible trapezium face, with the compass, is at an angle of 70°32' to the horizontal and that the square face adjoining it is at 54°44' to the horizontal.

Polyhedral sundials seem to have been manufactured in quantity in Nuremberg (Southern Germany), and surviving dials are designed for use at the latitude of Nuremberg, namely 45°. The latitude of Jean de Dinteville's château, at Polisy, in France, was a little over 48°. The latitude of London is about 51°30', so if the dial did belong to Jean de Dinteville, he would have found it more useful at home than in London — unless, of course, the dial was not a standard Nuremberg item but had been made specially for use in London (perhaps by Kratzer ?). It is, in any case, a moot point whether anyone would have tried to check up on the accuracy of a sundial. Both of Holbein's sitters would no doubt have been happy to quote the unkind comment by Seneca (d. 65 AD): 'I cannot tell you the hour exactly: it is easier to get agreement among philosophers than clocks.' *(Horam non possum certam tibi dicere: facilius inter philosophos quam inter horologia conveniet,* Seneca, *Apocolocynthosis,* 2.2. The word 'horologium' designates any kind of timekeeper.)

(a5) A brass torquetum, an instrument whose plates indicate planes of the circles associated with the various motions of celestial bodies. The instrument closely resembles one described and illustrated in the last part of Petrus Apianus, *Introductio geographica* (Ingolstadt, 1533). Apianus (1495 - 1552) claims to have invented this instrument. Holbein's picture of it may have been derived from Apianus' illustration (or from a version of it that was in circulation before the publication of the book itself?), but whereas Apianus shows the instrument as it might be used, Holbein shows it misaligned. In the circumstances, it is very difficult to believe that this 'mistake' is not deliberate. On the other hand, there is a spelling mistake in one of the inscriptions on the instrument. The words are impossible to see under normal viewing conditions, but close inspection shows that in one place Holbein has 'linea sodiaca' instead of 'linea zodiaca'.

(b) The wooden semicircle (a3) has scales which allow measurements below the horizontal, so it cannot have been designed only for astronomy — and in fact most instruments with a graduated rim also had a use in surveying. With this exception, the objects on the upper shelf refer exclusively to the science of astronomy. The objects on the lower shelf mainly refer to the other three 'mathematical sciences' recognized at the time: Geometry, Arithmetic and Music. From the left we have:

(b1) A terrestrial globe. Since it is the heavens that are believed to move, it is the celestial globe, not the terrestrial one, which has mountings designed to show rotation. In this period, geography was generally regarded as a subordinate part of astronomy. Almost in the centre of the part of the globe pointing directly towards the spectator there is a point marked 'Polisy', the location of the château belonging to Jean de Dinteville, where this picture was kept.

(b2) In front of the terrestrial globe there is an octavo book in a red leather binding, with black metal clasps. The book is held partly open by a brass version of a set square, showing a page of arithmetic. Its octavo format, and the nature of the text that is shown, with its array of Arabic numerals, indicate that the book is one dealing with

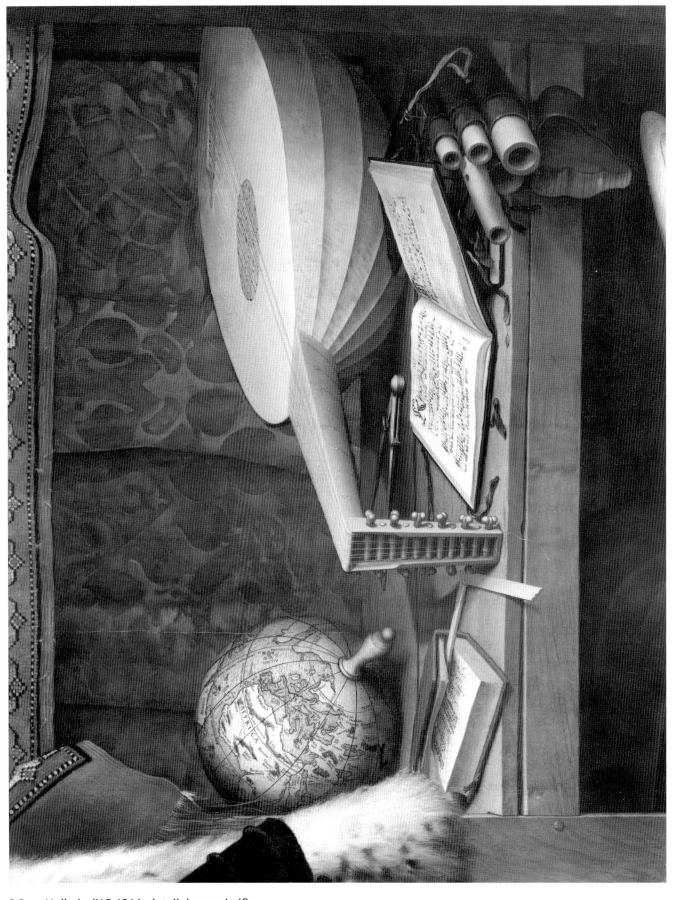

2.2 Holbein (NG 1314, detail, lower shelf)

so-called 'practical' or 'commercial' arithmetic, not the more abstract science of numbers that would have been found in learned university texts on the subject. The right-angled corner of the set square is hinged. The line of the hinge makes an angle of 45° with the outer edges of the rule, so the instrument can be folded back to give it a simple straight shape.

(b3) A pair of compasses, apparently made entirely of steel. Compasses were the usual symbol of the geometer. They were used for measuring distances on maps, or, like the set square, in the drawings associated with surveying.

(b4) A lute, a book of music (identifiable as showing a hymn by Martin Luther (1483 - 1546)) and a set of pipes that can presumably be assembled into a flute or a set of flutes. At this time, the theory of music was regarded as a mathematical science. Holbein's allusion seems, however, to be to the actual practice of music, just as the other objects on this lower shelf seem to refer to practical applications of mathematics in commercial arithmetic, surveying, geography and the like.

(c) For comments on the usefulness and collectability of small scientific instruments such as those shown in this picture, see the reference given for the next item, *Cognoscenti with pictures etc.* (NG 1287).

(d) The unreadable monochrome object in the foreground of the picture is a human skull, shown distorted in such a way that it looks correct if seen from a position close to the picture plane and about a quarter of the way up the right edge of the painting. (Holbein must have used some kind of mechanical device as an aid to drawing this part of his picture. For further comments see under 'Scientific information', entry 4.7 below.) Such anamorphic representations became popular in the late sixteenth century. The hidden nature of the image was sometimes assigned a spiritual significance. If the rather unsettling maladjustments of the astronomical instruments are to be taken as having an unhappy significance, and possibly as indications that the picture is concerned with mortality, the skull may well be regarded as a hidden key to its meaning.

References: Baltrušaitis (1977); Chapuis (1944)

NG 1314. ■ Plate, of whole + two details: upper shelf and lower shelf

2.3 Flemish School, c. 1620, *Cognoscenti with pictures etc.*, 95.9 x 123.5 cm.

The items on show include scientific instruments. On the left side of the table, at the back, there is a celestial globe (in a slightly less elaborate mounting than the one shown in Holbein's *Ambassadors*), and at the front of the table on the same side there is a moderately large planispheric astrolabe, which is partly hidden behind the standing man on the left. Beside the astrolabe there is a flat object that is probably some kind of folding rule. Between the globe and the astrolabe, and also partly hidden, is what seems to be a surveying instrument, of the type called a 'graphometer'. It has a graduated semicircle, and a movable arm with sights on it (an alidade). To the right, behind a scatter of medals, is a small portable sundial, of a design that allows it to be adjusted for use at different geographical latitudes. Beyond the medals, and a miniature painting, there is a small magnifying glass with an ornamental handle. On the far left, two men are carrying on a discussion which involves the use of a pair of compasses.

The astrolabe, which is shown in some detail, appears to be of a sixteenth-century Flemish type (the design of its star map is in the style associated with Arsenius). That is, for the people shown in the picture it is a fairly modern instrument. Its use would have been either in surveying (using the graduated rim and the alidade attached to the

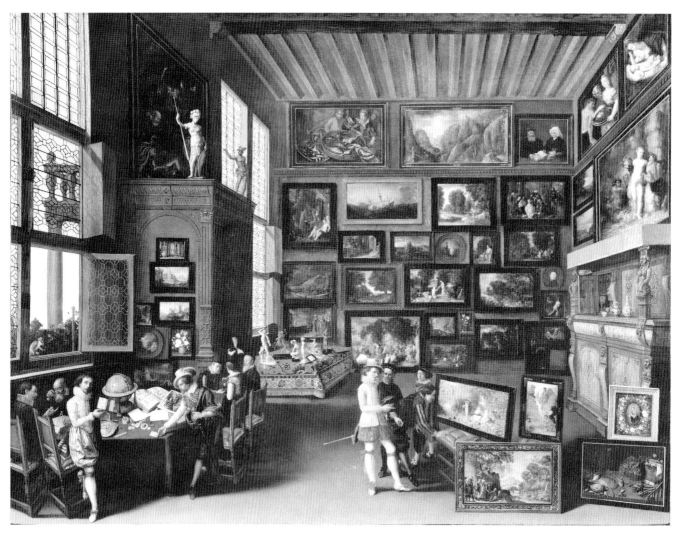

2.3 Flemish School (NG 1287)

back of the instrument), or as an aid to the teaching of astronomy (using the flat open-work star map on the front and demonstrating its rotation against the coordinate circles drawn on the plates visible under it).

Instruments very like those shown in this picture are to be found in museums in Britain and elsewhere. For comments on the usefulness and collectability of small scientific instruments like these, see Field (1988). For references to and illustrations of similar paintings which include instruments see Hill (1993).

References: Field (1988); Hill (1993).

NG 1287. ■ Plate, of whole + detail of instruments

2.4 Adriaen van Ostade (1610 - 1685), *An Alchemist,* signed and dated 1661, 34 x 45.2 cm.

There is a clutter of books and various vessels, including one that seems to contain mercury. A pair of bellows is being used on the furnace. The picture is very unlikely to be an accurate portrayal of an actual scene. Mercury was a metal much associated with alchemy at the time. The picture seems to represent a layman's view of arcane practices, and its purpose was probably purely as decoration. That is, it represents public interest in the doings of alchemists rather than shedding light on the practices themselves.

NG 846.

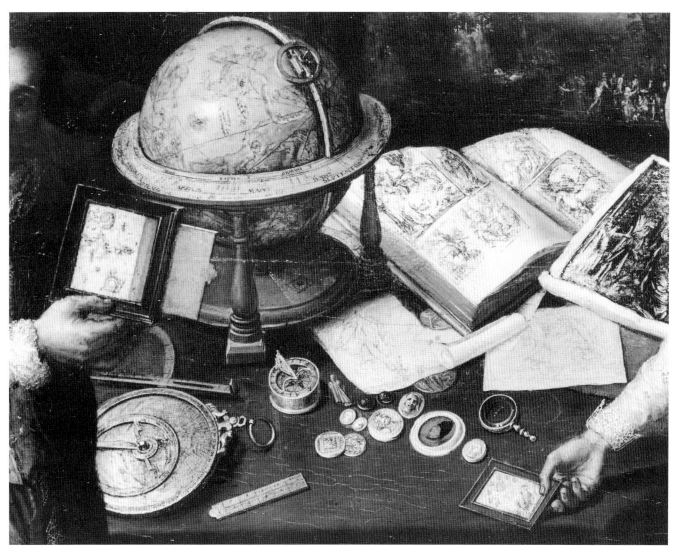

2.3 Flemish School (NG 1287, detail)

2.5 William Hogarth (1697 - 1764), *Mariage à la Mode,* Scene 3, *Visit to a Quack Doctor,* 69.9 x 90.8 cm.

There are various indications, for instance the fox's head, that the consultation is with a quack doctor. However if, as the programme of the series of pictures implies, the malady was venereal, an official physician, that is one licensed to practise by the Royal College of Physicians, would have been no more able to cure the disease than a quack doctor was.

Hogarth does not seem to have been particularly interested in mathematics or natural philosophy, but as a favour to a friend, John Joshua Kirby, he did provide a humorous frontispiece to a book about perspective, showing how the neglect of the scientific rules could lead to absurdities. (See William Hogarth, *Perspective Absurdities,* engraved frontispiece to John Joshua Kirby, *Dr Brook Taylor's Method of Perspective Made Easy in both Theory and Practice,* Ipswich, 1754.)

NG 115.

2.6 Joseph Wright of Derby (1734 -1797), *The Air Pump,* oil on canvas, signed and dated 1768, 182.9 x 243.9 cm.

Lectures on scientific subjects were a recognised form of elegant entertainment from the early eighteenth century onwards. It was usual for them to be enlivened with experimental demonstrations. (A descendant of the genre is to be found in the Christmas Lectures of the Royal Institution, which were initiated in 1826 by Michael Faraday (1791 - 1867).) In Wright's picture, an itinerant lecturer is giving a lecture demonstration on the properties of air. The demonstration in progress shows that when a vessel is evacuated a small bird enclosed in it first loses consciousness and

25

then dies. The bird can be revived if air is readmitted to the apparatus in time. It seems to be this piece of dramatically-timed manipulation that is shown in Wright's picture. The evident distress of one of the spectators is part of the drama, but may turn out to be less well founded than it seems — neither we nor the people in the picture know whether the bird is actually dead or merely unconscious. (The bird being used in the experiment has been identified as a white cockatoo, but may be an immature cockatiel. Like cockatoos, cockatiels originate in Australia, but unlike cockatoos they breed well in captivity.)

This demonstration is one of those performed before the Royal Society in the seventeenth century, using the first air pump, constructed by Robert Hooke (1635 - 1703) from a design by Robert Boyle (1627 - 1691). The pump shown in Wright's picture is of a very similar design. Boyle's work proved to be of great scientific importance — though King Charles II (reigned 1660 - 1685) is recorded as complaining that all his Society did was to weigh air, and Jonathan Swift (1667 - 1745) gave a cruel caricature of its apparently useless activities in his description of the Grand Academy of Lagado in Gulliver's Travels (1726). As can be seen in Wright's picture, in the longer run the public tended to take a more favourable view.

A companion piece to this picture, showing an astronomy lecture illustrated by the use of an orrery (a model of the Solar System) is in the City Art Gallery, Derby.

Reference: Egerton (1990).

NG 725. ■ Plate, of whole

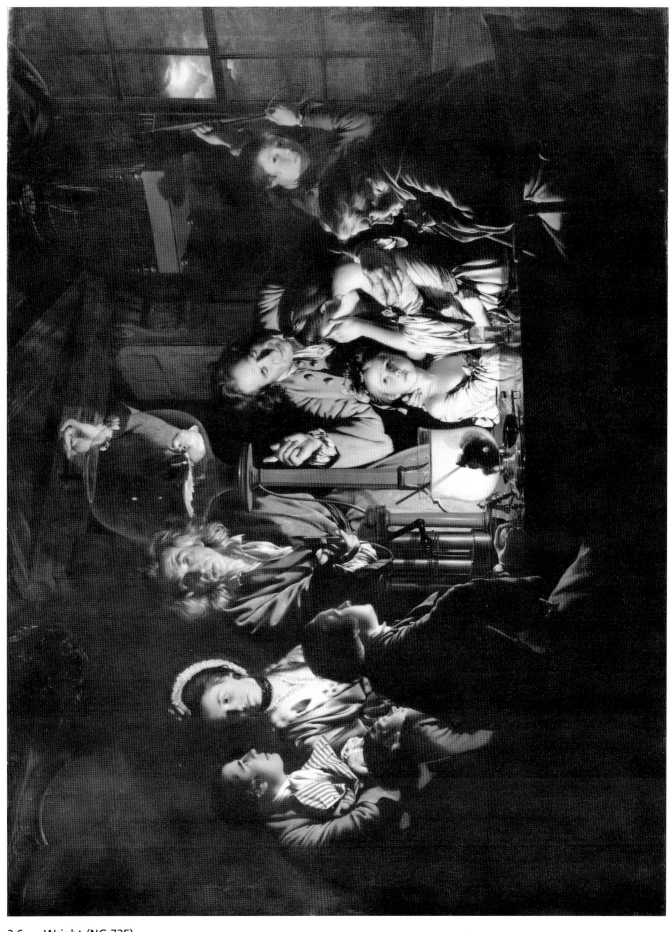

2.6 Wright (NG 725)

3. Mirrors

This section is concerned with specular reflection, that is with the reflection of light from smooth surfaces. It does not, for instance, consider the Impressionists' treatment of the streaky reflections from rippling water, or the broken glitter of rough water as painted by the Ruisdaels. We are concerned with the kind of reflection that could, in principle, have been treated in a more or less mathematically correct way.

The mathematical laws of reflection of light have been known since ancient times. They were passed on to the Middle Ages in the form of a treatise on mirrors ascribed to Euclid (fl. c. 300 BC, the author of the most famous of all mathematical texts *The Elements of Geometry*). Modern scholarship has questioned whether the treatise on mirrors is in fact by Euclid, but there is no doubt that it was widely studied. Reflection from a flat surface is very simple, but giving a mathematical description of reflection from curved surfaces is a much more awkward matter. There are Greek texts on the subject, but the fullest treatment was by the Muslim mathematician and natural philosopher Ibn al-Haytham (AD 965 - 1039), known in the West by the Latinised name Alhacen or Alhazen. It was not until the sixteenth century that books about optics were generally based upon the work of Ibn al-Haytham rather than that of Euclid. By then a true expert on optics needed to be a competent mathematician.

Artists seem generally to have used their eyes, that is their power of accurate observation, rather than attempting to make a detailed scientific study of the reflections concerned. For instance, despite the vivid impression of optical correctness that we have from the work of Jan van Eyck, it is really most unlikely that much mathematical learning went into his rendering of the reflection from the curved mirror in the background to the Arnolfini marriage portrait (NG 186). On the other hand, Velázquez is apparently relying upon the viewer of the *Rokeby Venus* (NG 2057) failing to notice that an elementary rule about reflection from a flat mirror has been ignored, but at the same time has taken care to omit enough of the edge of the mirror to make it impossible for us to actually work out what it should reflect (see below).

3.1 Jan van Eyck (fl.1422 , d.1441), *Portrait of Giovanni (?) Arnolfini and his wife Giovanna Cenami (?)*, ('The Arnolfini Marriage'), signed and dated 1434, 81.1 x 59.7 cm.

On the far wall there is a convex mirror with an apparently precise reflection. It is, however, very unlikely that the painter made any use of mathematics in constructing this image. The mathematics concerned would have been rather complicated. At this time, calculations of reflections from curved surfaces were regarded as essentially no more than difficult theoretical exercises to show off the professional competence of a mathematician (probably an astronomer).

NG 186. ■ Plate, of whole + detail of mirror

3.2 Piero della Francesca (c.1412-1492), *The Baptism of Christ*, 167 x 116 cm.

Piero della Francesca was known in his lifetime, and for a century or so thereafter, as a skilled mathematician, and the author of the first mathematical treatise on perspective construction. There is no reason to doubt his capacity for carrying out calculations to decide exactly what we should see reflected in the river. But we do not know whether he did so. What we see is an apparently exact rendering of such reflections, though the painting itself is not very detailed in the relevant passages, which are fairly far back in the picture space. The Baptism of Christ probably dates from the 1450s.

NG 665.

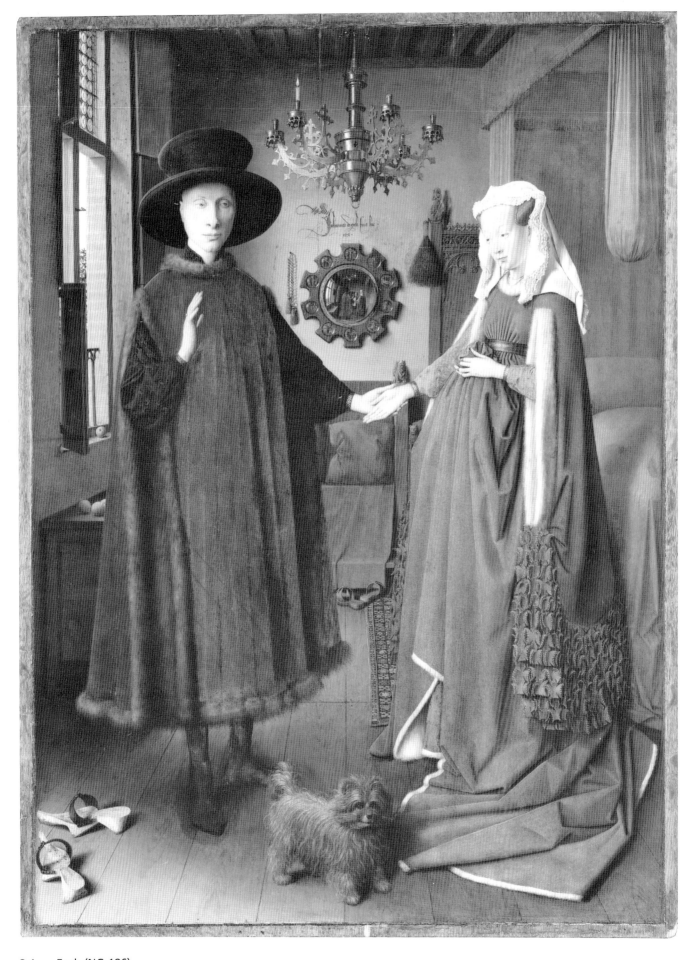

3.1 Eyck (NG 186)

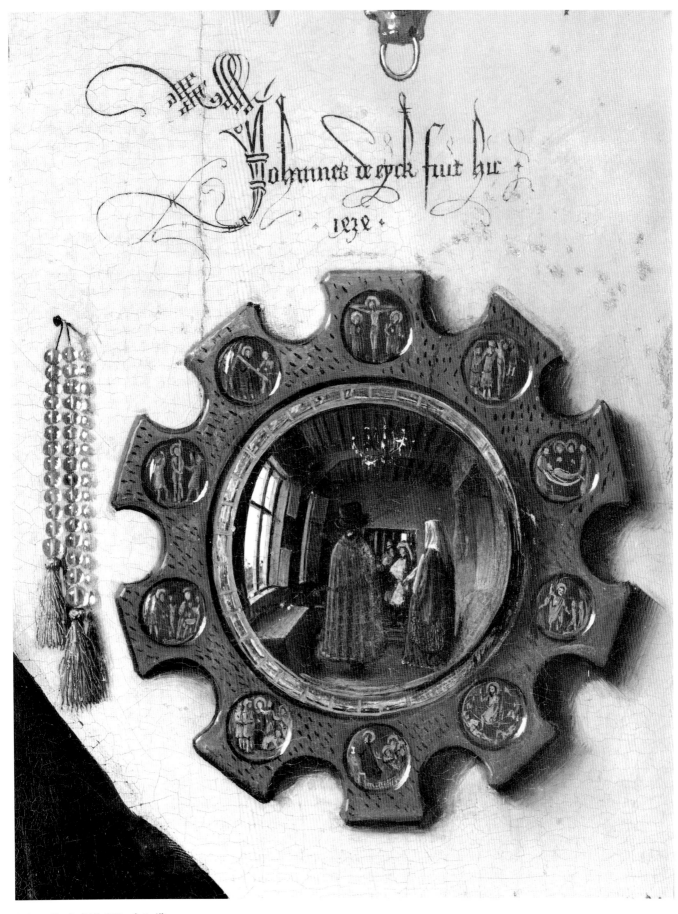

3.1 Eyck (NG 186, detail)

3.3 Piero della Francesca (c.1412-1492), *The Nativity,* 124.4 x 122.6 cm.

Apparently precise reflections are shown in the river in the background, and all the landscape is rendered with great attention to detail, very much in the Netherlandish manner. However, the dramatic foreshortening of St Joseph's leg (shown slung across his other knee so that the sole of the foot points almost straight at us) is a virtuoso use of perspective that is entirely Italian. The use of perspective in most of the picture is extremely discreet, but this one passage seems designed to remind us that Piero was, after all, an expert on this type of illusionism. The *Nativity* probably dates from the last years of Piero's life.

NG 908.

3.4 Hans Memling (c.1430/40 - 1494), *Triptych: The Virgin and Child with Saints and Donors (The Donne Triptych),* probably late 1470s, 70.8 x 70.5 cm.

The background gives a detailed treatment of reflections in water, with an undershot water mill and a road bridge.

NG 6275. ■ Plate, of detail (background)

3.5 Master of Moulins (fl.1483 - c.1500), *Charlemagne at the Meeting of Sts Joachim and Anna at the Golden Gate,* 71.8 x 59.1 cm.

There are detailed reflections from the semi-opaque glass globe held by Charlemagne.

NG 4092.

3.6 Master of Liesborn (active second half of 15th century), *Annunciation,* probably 1470 - 80, 98.7 x 70.5 cm.

A little reflection is shown in the background, but the overall perspective does not seem to be optically correct. On the other hand, the artist has given very convincing shiny surfaces to the metal objects shown on the cupboard in the left background.

NG 256.

3.7 Francesco Botticini (?) (Francesco di Giovanni, c.1446 - 1497), *Assumption of the Virgin,* 228.6 x 377.2 cm.

In the left background there are detailed reflections in the river and a road bridge.

NG 1126.

3.8 Domenico Ghirlandaio (1449 - 1494), *Virgin and Child,* 88.9 x 57.8 cm.

Netherlandish art was very fashionable in Florence at the time this picture was painted, and Ghirlandaio was a very fashionable painter (as well as a highly competent one). However, in this picture he has all but avoided putting in reflections from the water in the background. Compare Piero della Francesca's treatment of reflections (which is Netherlandish).

NG 3937.

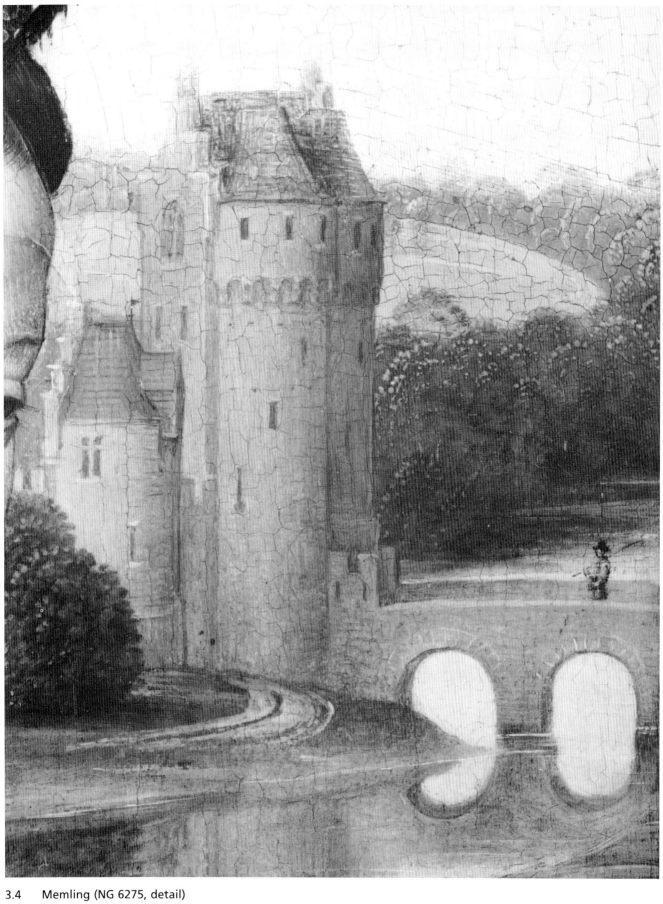

3.4 Memling (NG 6275, detail)

3.9 Gerard David (fl.1464, d.1523), *Deposition of Christ from the Cross,* 62.9 x 62.2 cm.

Detailed reflections.

NG 1078.

3.10 Follower of Leonardo da Vinci (1452 - 1519), *Narcissus,* 23.2 x 26.4 cm.

Specular reflection in the pool, but only of the simplest part of the figure.

NG 2673.

3.11 Nicolas Poussin (1594 - 1665), *Landscape with a man killed by a snake,* dated 1648, 119.4 x 198.8 cm.

Detailed reflections.

NG 5763.

3.12 Diego Velázquez (1599 - 1660), *Rokeby Venus,* probably 1647 - 51, 122.5 x 177 cm.

We cannot see enough of the edges of the mirror to allow us to decide exactly how it is placed with regard to the viewer of the picture or with regard to the figures in the picture. However, it is clear that the purpose of the mirror is to allow the model to make eye contact with the viewer. Since we do not know the precise position of the mirror, there is no secure mathematical basis for the assertion that what we should see in the mirror is the model's pubic hair (see Braham, 1976), though this suggestion may be considered to be in keeping with the spirit of the picture as a whole. The model's catching the viewer's eye was generally recognised at the time as sexually suggestive.

Contrary to the laws of optics, the reflected face has been made to appear the same size as our direct view of the head. However, in view of the sleight of hand in regard to the perspective of the mirror, and the fact that Velázquez's library contained a number of works on optics and perspective, it is to be presumed that this 'error' is entirely deliberate. No doubt Velázquez thought his picture looked better that way. (For Velázquez's library, see also the entry on his *Immaculate Conception* item 4.9 below.)

References: Sanchez Cantón (1925); Braham (1976); Field (forthcoming).

NG 2057. ■ Plate, of whole

3.13 David Teniers the Younger (1610 - 1690), *A View of Het Stercksdorf near Antwerp,* c. 1646, 82 x 115 cm.

Detailed reflections in water.

NG 817.

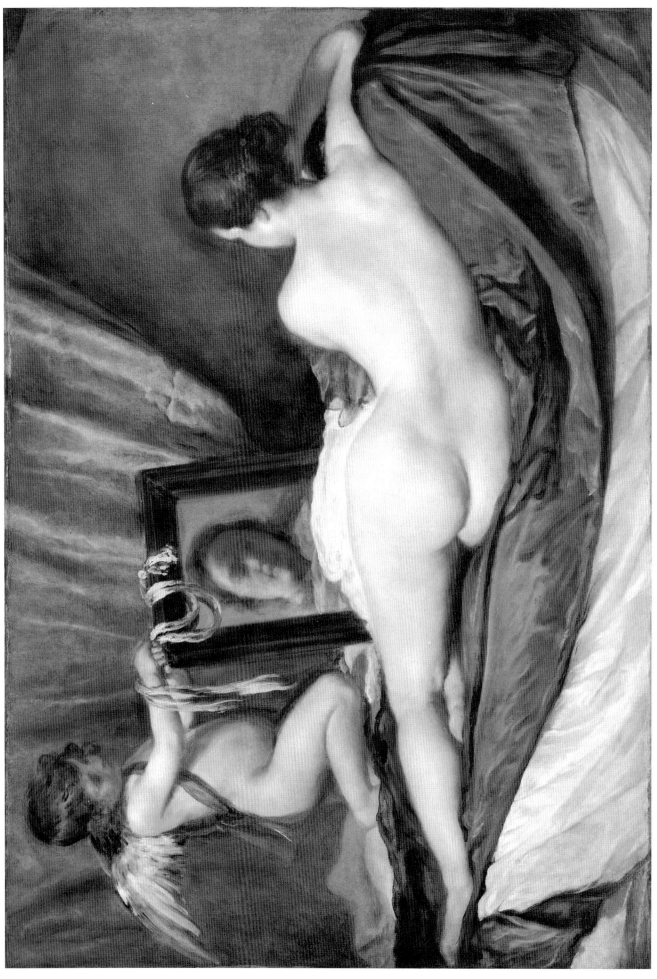

3.12 Veláquez (NG 2057)

3.14 School of Delft, 17th century, *Refusing the glass,* 117 x 92 cm.

There is a rather hazy rendering of reflection in what may be a mirror on the back wall of the room.

NG 2552.

3.15 Jan van der Heyden (1637 - 1712), *View of the Westerkerk, Amsterdam,* 91.5 x 116.2 cm.

The notably detailed rendering of the reflection in the canal makes an important contribution to the overall shape of the space in the picture.

NG 6526. ■ Plate, of whole

3.16 Ascribed to Gustave Courbet (1819 - 1877), *Landscape (L'Orage),* 83.2 x 105.4 cm.

The painter's dramatic use of specular reflection in the still waters of the river brings the cloud, and thus the storm, into the foreground of the picture. In principle this is exactly the same pictorial ploy as that used by Piero della Francesca to bring some blue, from the sky, into the foreground of his *Baptism of Christ* (see 3.2 above).

NG 4182.

3.15 Heyden (NG 6526)

3.17 Monet (NG 4240)

3.17 Claude Monet (1840 - 1926), *The waterlily pond,* dated 1899, 88.3 x 93.1 cm; and *Nymphéas,* after 1916, 200.7 x 426.7 cm.

The Impressionists were very interested in the correct rendering of colour and reflection of light.

Some of Monet's paintings of waterlilies treat the reflection in the surrounding water in such a way that, when one looks at the picture from a distance, one seems to be falling through the surface of the pool into the sky.

1899 picture, NG 4240; late one, NG 6343. ■ Plate, of whole

4. Scientific information

In this section we have included pictures which show something of the scientific information that the painter has incorporated into his work.

In several of these pictures, the painter would probably not have considered the information concerned as an important component of his work, but our distance in time gives the image a significance it did not have in its own day. For instance, in his picture of Christ of the Apocalypse (NG 579a, entry 4.1), Giovanni da Milano is merely displaying the standard fourteenth-century theory of the cosmos by showing the heavens as a blue sphere patterned with stars. The interest of this image is that it is, in fact, more literal to the scientific truth of its day than may at first appear to the modern viewer of Giovanni's picture. Similarly, a detailed study of Filippo Lippi's *Annunciation* (NG 666, entry 4.5) has shown that it displays some characteristically fifteenth-century ideas about light and its properties. On the other hand, in spite of the rather naturalistic style of the picture as a whole, Velázquez' depiction of the Moon in his *Immaculate Conception* (NG 6424, entry 4.9) is decidedly not in accord with early seventeenth-century astronomy.

Other pictures have been included in our list because they show an interest in the scientific knowledge of the world, for instance in displaying maps (for their use as household decoration, see Alpers, 1983) or in recording the public display of a rhinoceros in eighteenth-century Venice (NG 1101, entry 4.13).

We have also included Holbein's *The Ambassadors* (entry 4.7), for its anamorphic perspective of a skull (presumably drawn with the help of some kind of perspective instrument), as well as a few pictures and a peepshow which display a grasp of the scientific principles of perspective, or at least a serious interest in them. (On perspective instruments and painters' sometimes cavalier attitude to perspective see Kemp (1990), and Field (1997).)

We have omitted references to pictures which show inherently non-identifiable phenomena. One such is Dürer's *St Jerome* (NG 6563) whose reverse shows what seems to be a catastrophic event, possibly involving a fireball. It has been suggested that Dürer has shown a comet. We can see no reason for this identification. At the time the picture was painted (about 1495), comets were considered to be relatively small scale meteorological phenomena, whose significance was as portents rather than as catastrophes, or direct causes of catastrophes, in their own right. Thus this scene, which is presumably connected with the end of the world, seems more likely to refer not to a comet but to one of the greater events described in the book of *Revelation*. It does not appear to be an attempt to give an exact account of any particular natural phenomenon.

4.1 Giovanni da Milano (active 1346 - 1369(?)), *Virgin, Christ of the Apocalypse and St John,* each panel 90 x 38 cm.

These panels are part of an altarpiece. Christ is shown holding a symbolic representation of the heavens, in the form of a blue globe with golden stars on it. At this time, in the Christian West, it was generally believed that the 'fixed stars', that is those that made up the patterns of the constellations, were attached to a sphere which rotated once a day. Below that sphere were the spheres carrying the planets. The Earth was at rest in the centre of the system. That is, the Earth was in the lowest and humblest place in the Universe, furthest from the highest heaven — above the sphere of stars — which was the home of God and His angels. This cosmological system is a christianised version of the Ancient geocentric system derived from the natural philosophy of Aristotle (384 - 322 BC) and described in terms of technical astronomy in the *Almagest* of Claudius Ptolemy (fl. AD 129 -141).

For a sixteenth-century representation of the Universe, see entry 2.1 above.

4.1 Giovanni da Milano (NG 579a)

4.2 Masaccio (Tommaso di Giovanni, 1401 - c.1429), *Madonna and Child with Angels* ('The Pisa Madonna'), 1426, 135.3 x 73 cm.

A mathematical 'rule' for drawing in correct perspective was invented by Filippo Brunelleschi (1377 - 1446) in, or a little before, 1413. However, the two panels that he painted to show off his skill have been lost. This painting by Masaccio, which is probably part of the central panel of an altarpiece, is among the earliest surviving works of art that show Renaissance constructed perspective. The lines of the throne that, in the imagined reality, would be perpendicular to the picture plane, have been angled so that if they were extended they would all meet at a point very close to the tip of the toe of the Child's lower foot. That is to say that the drawing of the throne has what would later be called a 'vanishing point'. Moreover, Masaccio seems to have arranged for this point to be at the height of the eye of a viewer standing in front of the altar on which the picture was placed.

Constructed perspective requires the position of the viewer's eye to be decided in advance. Such mathematically correct illusionism is not really practical — except for a peepshow (see the example by van Hoogstraten, entry 4.11 below). At the least, people may be expected to kneel as well as to stand in front of an altarpiece. However, it turns out that the illusion of depth is surprisingly robust: pictures continue to look right when seen from the wrong place, and pictures that are far from mathematically correct nevertheless look convincing. Artists, including Masaccio, seem to have recognized this from the beginning. In fact, constructed perspective is only one means which painters use to construct a sense of space. For instance, in this picture the illusion of a third dimension is strongly reinforced by the painting of cast shadows and the modelling of the figures. Notice the shadow of the Madonna on the right side of the throne, and the emphasis on the heavy folds of the drapery over the Madonna's knees.

References: Field (1997); Hills (1987); Kemp (1990); Gombrich (1995).

NG 3046. ■ Plate, of whole

4.3 Paolo Uccello (1397 - 1475), *Niccolò da Tolentino at the Battle of San Romano*, 1450s, 181.6 x 320 cm.

Uccello is known to have been an enthusiastic practitioner of constructed perspective. In this picture he has shown lances, lying on the ground, that define lines perpendicular to the picture plane ('orthogonals'), and parallel to it ('transversals'), but it is clear that the illusion of solid forms in real space is mainly dependent on the modelling of the figures, particularly the horses. Compare Uccello's *St George and the Dragon* (NG 6294, see entry 4.4 below). Compare also Masaccio's *Madonna and Child* (NG 3046), entry 4.2 above.

NG 583.

4.4 Paolo Uccello (1397 - 1475), St George and the Dragon, c. 1460, 56.5 x 74.3 cm.

Straight edges of patches of grass show a tendency to align themselves to produce orthogonals and transversals. See the comment on Uccello's battle scene (NG 583), entry 4.3 above.

NG 6294. ■ Plate, of whole

4.2 Masaccio (NG 3046)

4.4 Uccello (NG 6294)

4.5 Fra Filippo Lippi (c.1406 - 1469), *Annunciation,* c. 1455, 68.6 x 152.4 cm.

A detailed study of this picture has shown that it very probably expresses some well-established fifteenth-century ideas about the properties of light, and theories about generation, that associate light with seminal fluid. It is the light from the holy dove which is causing Mary to conceive.

The belief that spinal fluid, seminal fluid and the material of 'visual rays' (the beams believed to be emitted by the eye in the process of vision) were all the same goes back to the Ancient World — and is the basis of the curious belief, current as late as the early twentieth century, that masturbation makes one go blind.

The theory that sight was by the reception of light rays rather than the emission of eye beams was put forward by several medieval natural philosophers, most notably Ibn al-Haytham (c. AD 965 - 1040, known in the West as Alhacen or Alhazen). However, it did not find much favour — probably because it is much more convincing, psychologically, to think of sight as an active process. The truth of the matter, namely that sight was indeed by reception of light, was established by Johannes Kepler (1571 - 1630) in 1604. His work was accepted very quickly (possibly because physicians noticed it had no consequences at all for the treatment of patients).

Reference: Edgerton (1991), pp.88 - 107.

NG 666.

42

4.6 Piero della Francesca (c.1412-1492), *The Nativity.*

Use of perspective. See under 'Mirrors', entry 3.3 above.

<div align="right">NG 908.</div>

4.7 Hans Holbein (1497/8 - 1543), *The Ambassadors,* signed and dated 1533 (inscription in perspective on the floor at the left), 207 x 209.5 cm.

The picture includes a drawing of a human skull, which would look correct if seen from a point close to the picture plane and about a quarter of the way up the right edge of the painting. Some kind of mechanical device was no doubt used as an aid to producing this anamorphism — and may also have been used for the inscription.

Anamorphisms became popular towards the end of the sixteenth century, This seems to be an early example. There is another in the anamorphic portrait of King Edward VI of England (reigned 1547 - 53) in the National Portrait Gallery (London).

For a discussion of other elements in *The Ambassadors* see entry 2.2 above.

Reference: Baltrušaitis (1977)

<div align="right">NG 1314.</div>

4.8 Pieter Saenredam (1597 - 1665), *Interior of the Great Church at Haarlem,* 1636 - 37, 59.5 x 81.7 cm.

Saenredam is known to have made detailed perspective studies to provide a correct optical basis for his pictures. This may partly account for the very convincing nature of the pictorial space, but, as in the work of Piero della Francesca, the spaciousness of the pictures clearly also depends upon the painter's very subtle rendering of the flow of light.

Reference: Kemp (1984).

<div align="right">NG 2531. ■ Plate, of whole</div>

4.9 Diego Velázquez (1599 - 1660), *The Immaculate Conception,* about 1618, 135 x 101.6 cm.

The picture includes a highly stylised schematic Moon, which is apparently a shiny transparent bubble. This is in accordance with older conventions in religious art, but contrary to contemporary astronomical opinion about the Moon. It had been recognised since Ancient times that the Moon was opaque, and that eclipses of the Sun were caused by the interposition of its body between Earth and Sun. Moreover, in Velázquez's own time Galileo Galilei made important discoveries about the nature of the lunar surface, and published them in a short book which became instantly famous, his *Message from the stars (Sidereus Nuncius,* Venice, 1610). Naturally enough, not everyone chose to believe what Galileo claimed to have seen through his telescopes, but his friend the painter Cigoli (Ludovico Cardi, 1559 - 1613) used Galileo's drawings of the Moon in his fresco of the Immaculate Conception in the small dome of the Cappella Paolina in Santa Maria Maggiore, Rome (see Kemp, 1990, p.96).

Velázquez's more conservative attitude is probably to be ascribed to his patron's instructions rather than to ignorance of astronomy on the painter's part. The inventory taken of his library at his death suggests he did, in fact, at least later in life, take

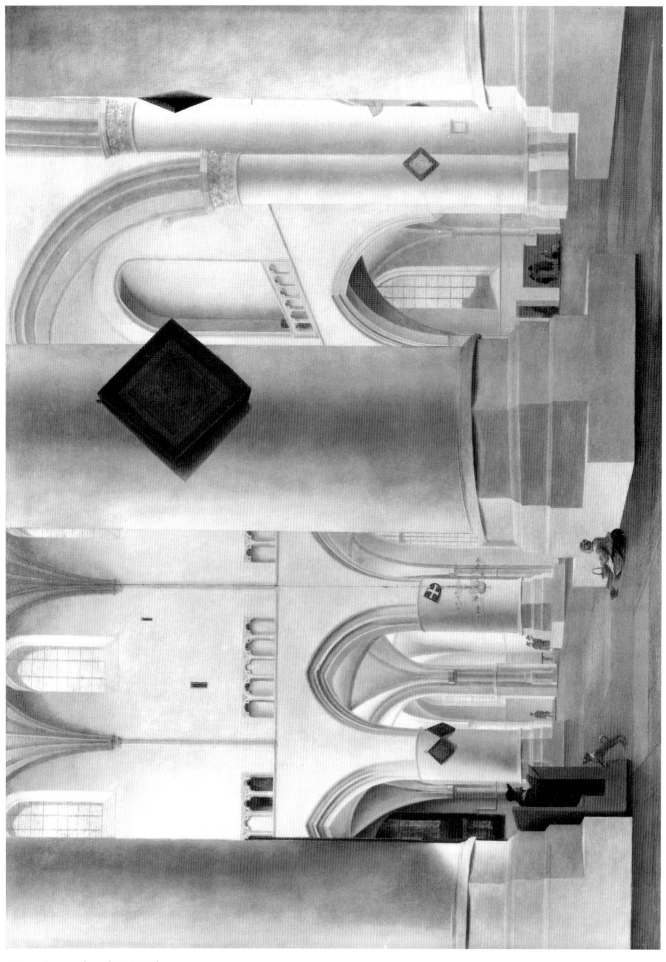

4.8 Saenredam (NG 2531)

an interest in much of the scientific activity of his time — though he does not seem to have owned any books by Galileo (who had been condemned by the Inquisition in Rome as 'vehemently suspected of heresy' in 1633 — so his books were not likely to be acceptable in ultra-Catholic Spain). However, Velázquez did own several general works on astronomy, any one of which would have told him that the moon was not in fact as he had shown it in this picture, and there is reason to suppose that his elementary education would have included this kind of information.

References: Sanchez Cantón (1925); Field (forthcoming); Kemp (1990).

NG 6424. ■ Plate, of whole + detail to show Moon

4.10 Carel Fabritius (1622 - 1654), *View of Delft,* dated 1652, 15.4 x 31.6 cm.

Fabritius was Rembrandt's most gifted pupil. The National Gallery also has a fine self portrait by him (NG 4042, signed and dated 1654). This view of the city of Delft, apparently designed to be seen not flat but curved, may have formed part of a peepshow. The exact location of this view can be identified. The picture shows a canal with a bridge.

NG 3714.

4.11 Samuel van Hoogstraten (1627 - 1678), *Peepshow, with Views of the Interior of a Dutch House,* 58 x 88 x 63.5 cm.

Through the viewing holes one sees the interior of a house. Examining the inside of the box reveals a quite complicated use of perspective to achieve this illusion.

NG 3832. ■ Plate, of detail

4.12 Jacob Ochtervelt (1634 - 1682), *A musical party,* probably 1675 - 80, 84.5 x 75 cm.

There is a map, rather vaguely rendered, hanging on the back wall of the room. At this period, maps were often hung on walls as decoration.

NG 3864.

4.13 Pietro Longhi (Pietro Falea, 1702 (?) - 1785), *Exhibition of a Rhinoceros at Venice,* c.1751, 60.4 x 47 cm.

The animal shown is a young female great Indian rhinoceros that was owned by Captain Douwe Mout van der Meer. It was shown in various places all over Europe for about twenty years. The animal's horn has apparently been broken off (possibly accidentally) and is being brandished by one of the spectators. Exotic animals had been an attraction at least since the days of Ancient Rome, and they appear in many pictures in the National Gallery (for instance there are two cheetahs in Titian's *Bacchus and Ariadne,* NG 35). Longhi's picture is significant in showing an exhibition of an animal as a scene (or a social event) in its own right (compare Wright's *Air Pump,* NG 725, entry 2.6 above). Moreover, care seems to have been taken to make an accurate record of the appearance of the rhinoceros.

Reference: Clarke (1986).

NG 1101.

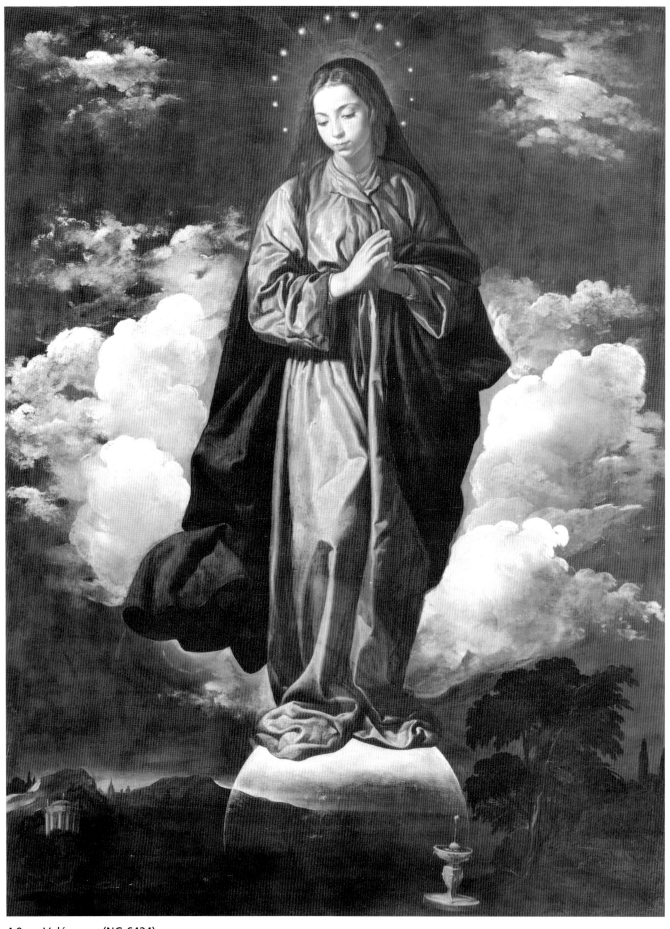

4.9 Velázquez (NG 6424)

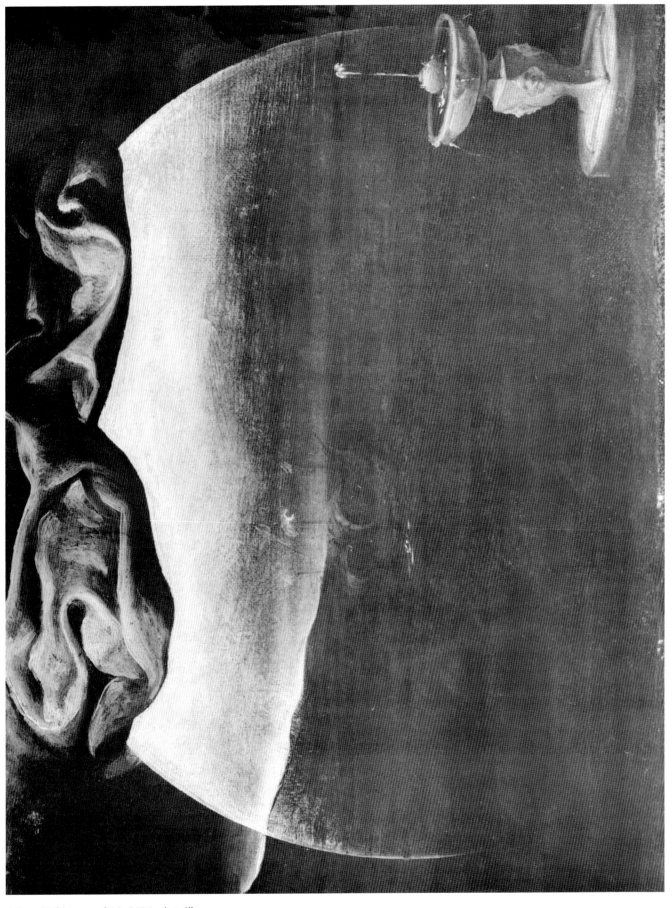

4.9 Velázquez (NG 6424, detail)

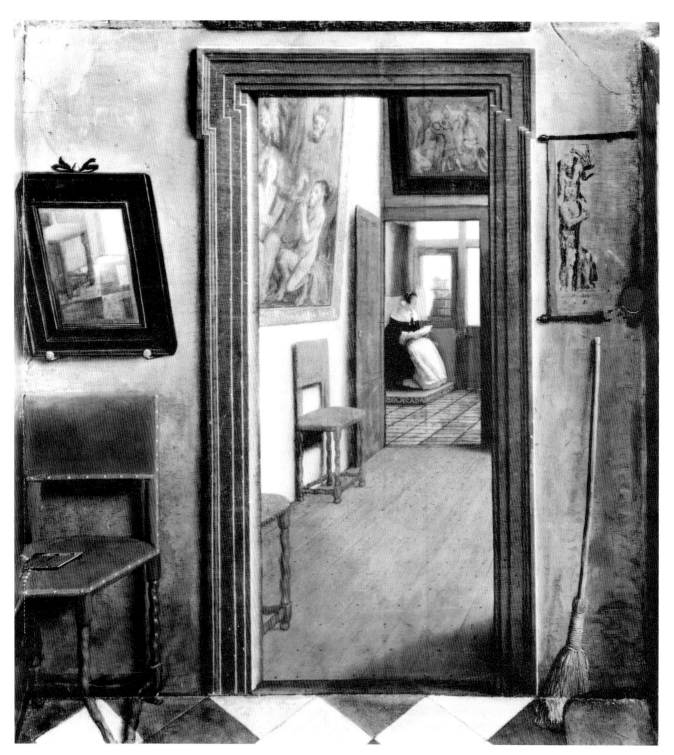

4.11 Hoogstraten (NG 3832)

4.14 Pompeo Batoni (1708 - 1787), *Portrait of a Gentleman,* probably 1760s, 134.6 x 96.3 cm.

The sitter is pointing at a map showing the Adriatic and surrounding coast.

NG 6459.

4.15 François-Hubert Drouais (1727 - 1775), *Portrait of the Comte de Vaudreuil,* dated 1759, 225.4 x 161.3 cm.

The Comte de Vaudreuil (1740 - 1817) was the son of a French governor of Santo Domingo (now the Dominican Republic). He is holding onto a map that is attached to the wall, and is indicating on it the position of his birthplace (Santo Domingo, West Indies).

NG 4253.

5. Meteorological phenomena

This section mainly considers unusual meteorological phenomena, such as the rainbow and lightning. There is, of course, a huge number of pictures that show representations of more ordinary things, such as rainstorms and clouds. One of the first painters to make a serious study of the different forms of cloud was John Constable (1776 - 1837), and the National Gallery is fortunate in having many paintings which show the good use he made of his scientific studies in his finished paintings. His rendering of the rainbow (in one of his series of pictures of Salisbury Cathedral, I.47, see below) seems more tentative than his rendering of clouds.

The rainbow is a very striking sight, so its relative rarity in pictures is perhaps somewhat surprising — though there are paintings, not in the National Gallery, showing rainbows by Ruisdael and Rubens. Moreover, the National Gallery seems to lack pictures of the Apocalypse, one standard religious subject in which a rainbow usually appears, since it is mentioned in St John's text. The National Gallery's only Christ of the Apocalypse does not shows Him 'sitting on the rainbow', but does give Him a 'sphere of the heavens' (see entry 4.1 above). The two illustrations of rainbows listed here date from the nineteenth century, when the scientific explanation of the phenomenon was part of general knowledge. The colours used by both artists, Constable and Seurat, seem a tribute more to the part played by raindrops than to the part played by sunlight.

The two illustrations of lightning in our list show only the path of the light, rather than the dramatic effect of sudden illumination.

Rather than omit clouds altogether, or put them all in, thus making this section unmanageably long, we decided to include only a few relatively early examples of possibly naturalistic clouds, shown in pictures by Giovanni Bellini (c.1430 - 1516), Andrea Mantegna (1431 - 1506) and Carlo Crivelli (early 1430s - 1494 (?)). These paintings are close together both culturally and in the Gallery's display, and can thus easily be compared one with another.

5.1 Giovanni Bellini (c.1430 - 1516), *The Blood of the Redeemer,* 1460 - 65, 47 x 34.3 cm.

The clouds are in thinner layers, but are otherwise rather similar to those in Bellini's *Agony in the Garden.*

NG 1233.

5.2 Giovanni Bellini (c.1430 - 1516), *The Agony in the Garden,* after 1465, 81.3 x 127 cm.

The clouds look convincingly soft-edged, vaporous and insubstantial, dark with symbolism of Christ's suffering and lit with the warm colour of the dawn that signifies hope of salvation. However, the light is not in fact treated completely naturalistically: we see the dawn behind the figure of Christ, but the soles of His feet are lit from the opposite direction.

NG 726.

5.3 Andrea Mantegna (1431 - 1506), *The Agony in the Garden,* c. 1460, 62.9 x 80 cm.

Mantegna worked briefly in the workshop in which Giovanni Bellini was trained — that of his father Jacopo Bellini (c.1400 -1470/1). Giovanni Bellini's early style

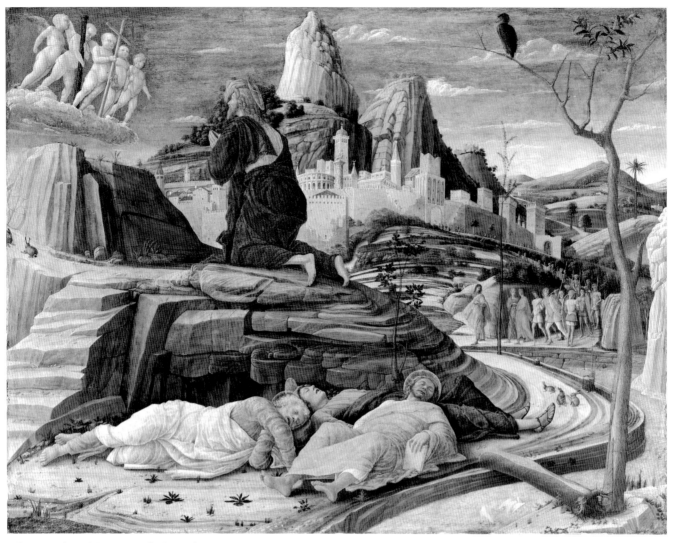

5.3 Andrea Mantegna (NG1417)

somewhat resembles Mantegna's. However, in later life their styles of painting became in some respects very different. Their treatment of clouds provides a trivial example of this: Mantegna's clouds tend, as here, to look much more solid than Bellini's do. Their shapes are almost sculptural. Indeed, in some of Mantegna's pictures the clouds look as if they were made of stone.

NG 1417. ■ Plate, of whole

5.4 Carlo Crivelli (early 1430s - 1494 (?)), *Vision of the Blessed Gabriele,*
 141 x 87 cm.

The clouds are heavy and streaky.

NG 668.

5.5 Carlo Crivelli (early 1430s - 1494 (?)), *The Annunciation with St Emidius,*
 signed and dated 1486, 207 x 146.7 cm.

Although the scene in the picture is different, Crivelli's treatment of the clouds is very similar to that in *The Vision of the Blessed Gabriele* (see above).

NG 739.

5.6 Francisque Millet (1642 - 1679), *Mountain landscape with lightning,*
 1660 - 79, 97.2 x 127 cm.

The lightning is shown simply as a wide bright streak.

NG 5593. ■ Plate, of whole

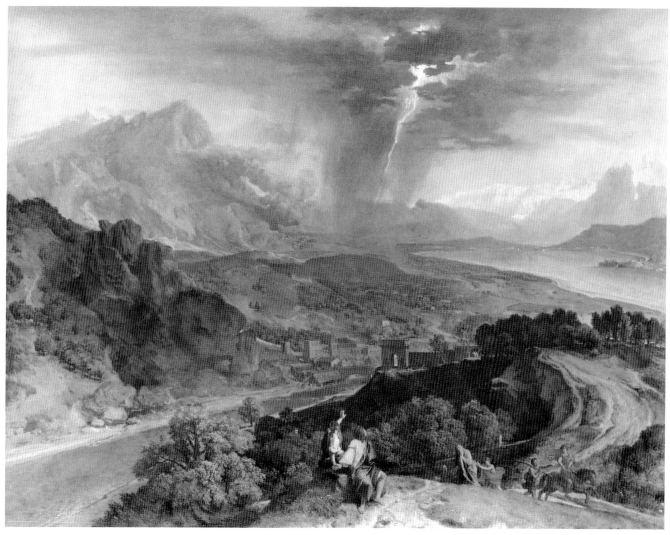

5.6 Millet (NG 5593)

5.7 John Constable (1776 - 1837), *Salisbury Cathedral from the meadows,*
 1831 - 34, 52.7 x 76.8 cm.

 Shows a rainbow. A heavy farm cart is being pulled across a ford.

 L.47

5.8 Henri Rousseau (Le Douanier Rousseau, 1844 - 1910), *Tropical Storm,*
 signed and dated 1891, 129.8 x 161.9 cm.

 Shows highly diagrammatic lightning. The picture is believed to have been inspired
 by a visit to the Jardin des Plantes in Paris.

 NG 6421.

5.9 Georges Seurat (1859 - 1891), *The Rainbow* (a study for Bathers at
 Asnières), 15.5 x 24.5 cm.

 The background shows a rainbow and a factory at Asnières

 Reference: House (1980)

 NG 6555. ■ Plate, of whole

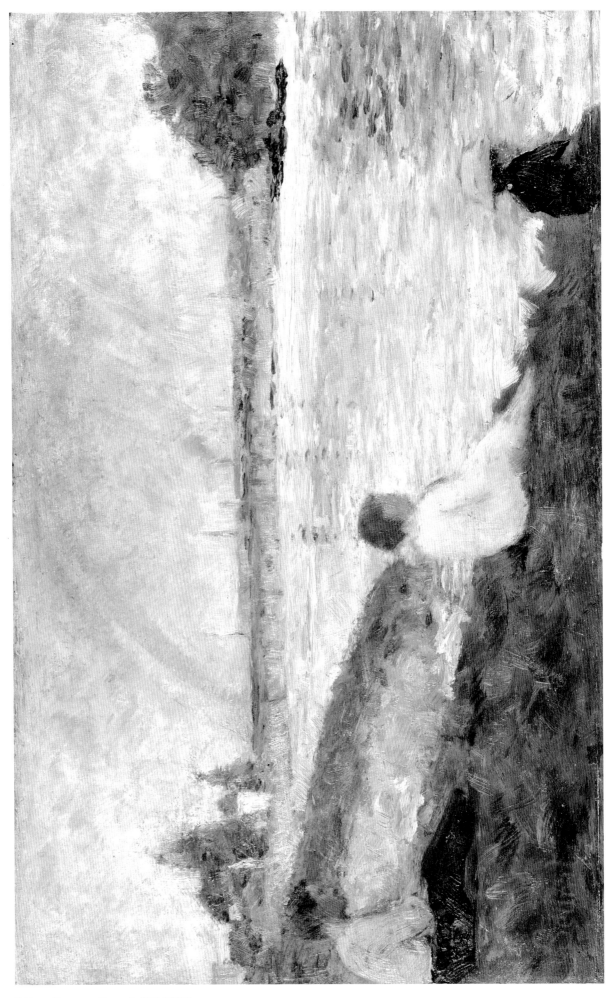

5.9 Georges Seurat (NG 6555)

6. Waterwheels

From late Roman times until the nineteenth century, waterwheels were the chief source of power supply in Europe. A crude wheel could do the work of twenty people. On average, wheels did the work of fifty.

Horizontal waterwheels, that is wheels whose circumference is horizontal (and whose axis of rotation is therefore vertical), are known to have been in use in Europe by the first century BC. The most recent example of this type of mill is one in the Shetland Islands, recorded as in use in 1933. The vertical waterwheel (with vertical circumference and horizontal axis) also appeared in the first century BC. Vertical wheels can be moved either by water flowing under them (an 'undershot' wheel) or by water flowing onto them from above (an 'overshot' wheel). The overshot wheel makes more efficient use of the flow since a given volume of water is in contact with the wheel for a longer time, the wheel being moved by the weight of the water that flows over it. An undershot wheel is turned by the strength of the current in the water flowing under it. However, undershot wheels were more common, as being easier to construct. Both horizontal and vertical waterwheels are described in Vitruvius' treatise *On architecture,* written in the late first century BC, which contains quite a lot of information about Roman machinery and its uses.

By the time the Western part of the Roman Empire was overrun by the Goths, in the late fifth century AD, water-driven mills for grinding grain to make flour were already widely distributed: archaeologists have found the remains of such water mills in Athens (Greece), Arles (Southern France), in a settlement in Kent (Southern Britain) and in settlements along the northern frontier of Britain close to Hadrian's wall. Water mills continued in use during the following centuries. The Domesday Book records that in 1086 there were 5,624 water mills in England. In 1130, a visitor, Arnold de Bruneval, noted that in the newly rebuilt Abbey of Clairvaux (in France) water power contributed to the making of bread and beer, the fulling of cloth, the tanning of leather and finally the carrying away of waste.

The use of water power increased throughout the Middle Ages. There were more mills, and their uses were more varied. In the twelfth century water power was applied to crushing ore (as a preliminary to smelting), to tanning leather, and to the production of sugar. In the thirteenth century water mills were used in paper-making and to drive bellows. In the fourteenth century they were used in pumping water out of mines and in the manufacture of paint. In the fifteenth century they were used for boring pipes, and in the sixteenth for polishing gems and minting coinage. At the beginning of Schubert's song cycle *Die Schöne Müllerin* ('The miller's beautiful daughter'), a young man sees a stream and concludes that there must be a mill nearby. The poems Schubert set, which were written by Wilhelm Müller (1794 - 1827), were first published in the 1820s, but the deduction would have been a reasonable one at any time in the previous millennium.

Given how common water mills were, it is striking that there are so few pictures of them among the many paintings of landscapes, in the National Gallery and in other collections. Presumably water mills were generally regarded as too ordinary to be worth much attention. The example by Boucher (dated 1736) seems to be part of a sentimentalised vision of rural life, and even Constable's many much more realistic pictures of mills in his native Suffolk, painted in the early nineteenth century, carry a certain weight of nostalgic childhood memory about them. Most painters of landscape must simply have omitted the mills — presumably as merely cluttering up an otherwise pleasant view. Water mills were crucial to the functioning of the economy of the day, but painters and their patrons were apparently happy to ignore them. In the same way, landscape artists of our own time tend to pay little attention to electricity pylons.

6.4 Claude (NG 12)

6.1 Hans Memling (c.1430/40 - 1494), *The Donne Triptych.*

Background shows a water mill. See under 'Mirrors', entry 3.4 above.

NG 6275.

6.2 Master of the Female half-lengths (c.1525 - 1550, *The Rest on the Flight into Egypt,* 81.9 x 62.2 cm.

In the background there is a mill with an undershot waterwheel.

NG 720.

6.3 Garofalo (Benvenuto Tisi, 1481(?) - 1559), *Allegory of Love,* 127 x 177.8 cm.

In the left background there is a mill with an undershot waterwheel.

NG 1362.

6.4 Claude Gellée (Claude Lorrain, 1600 - 1682), *Landscape with the Marriage of Isaac and Rebecca,* signed and dated 1648, 149.2 x 196.9 cm.

Includes an overshot waterwheel. This design of waterwheel was more common in Italy, where Claude worked, than in northern countries. Overshot wheels can function satisfactorily with a lower rate of flow than that required for undershot wheels, since they use the water more efficiently (see Introduction above).

NG 12. ■ Plate, of whole + detail to show waterwheel

6.5 Jacob van Ruisdael (1628/9 - 1682), *Two Water Mills and an Open Sluice near Singraven,* 87.3 x 111.5 cm.

Ruisdael is notable for his interest in painting scenes that include flowing water. This picture shows undershot waterwheels. Compare following item, by Hobbema (NG 832).

NG 986. ■ Plate, of whole

6.6 Meindert Hobbema (1638 - 1709), *The Watermills at Singraven near Denekamp,* probably 1665 - 70, 60 x 84.5 cm.

Shows an undershot waterwheel. Compare previous item, by Jacob van Ruisdael (NG 986).

NG 832.

6.7 François Boucher (1703 - 1770), *Imaginary landscape,* signed and dated 1736, 57.2 x 73 cm.

The painting shows a winsome tumbledown mill with an undershot waterwheel, and a neat stone bridge behind. This is a pictorial counterpart to Queen Marie Antoinette's playing at being a milkmaid. That is, it tells one about a taste for a sweetened version of rural simplicity, not about actual landscape or actual water mills.

NG 6374.

6.8 John Constable (1776 - 1837), *Stratford Mill,* 127 x 182.9 cm.

The mill has an undershot waterwheel. There is a barge passing on the waterway.

NG 6510.

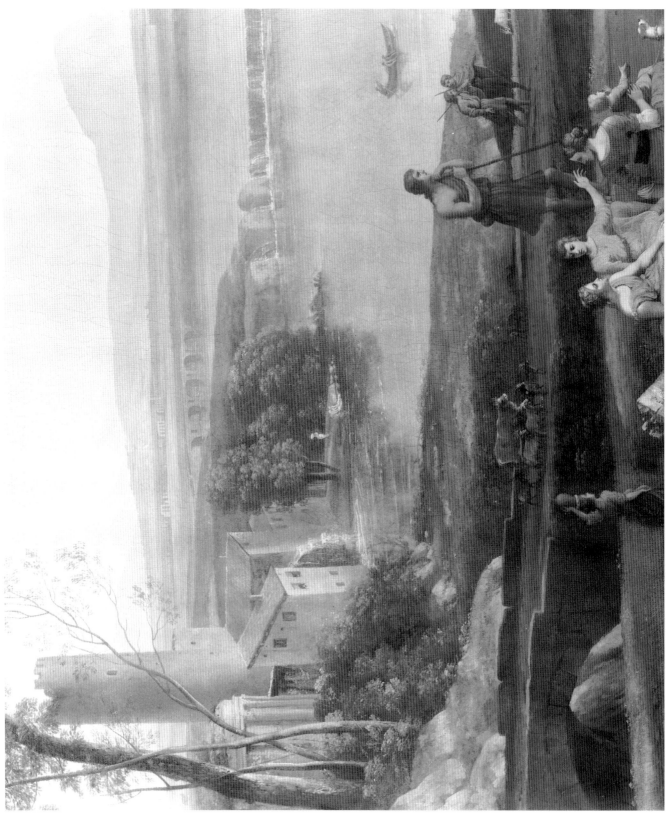

6.4 Claude (NG 12, detail)

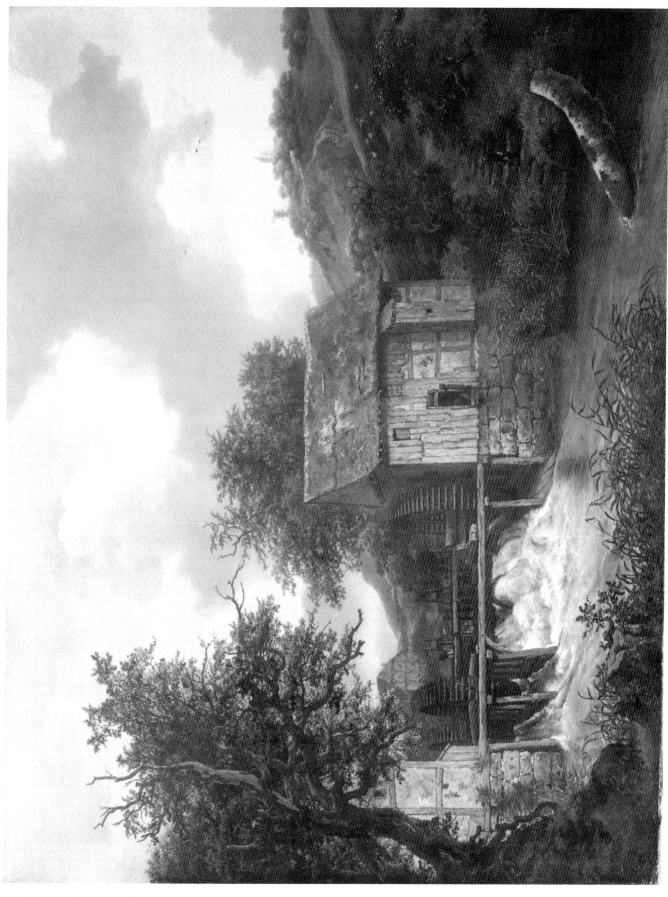

6.5 Ruisdael (NG 986)

7. Windmills

Air is less dense than water, so that, volume for volume, it carries less power. Thus, windmills are inefficient compared to water mills. This fact was well known long before any scientific explanation was offered. Windmills were constructed almost exclusively either in areas where running water was not easily available (for example on tops of hills, as in Spain — see *Don Quixote* — or in Sussex, in Southern England), or in flat low lying regions where there was no restraint on the wind (for instance, in the Low Countries or East Anglia, in Eastern England). Our list of windmills in pictures in the National Gallery includes only one painting that is not by a Dutch artist of the seventeenth century, and that one shows a windmill in a flat region in the North of France. We have chosen pictures in which the windmill is depicted in some detail. Given the constraints for their location, windmills were often visible from a distance, and tiny sketches of them accordingly appear in the backgrounds of quite a number of pictures.

To use the wind as efficiently as possible, the sails of a windmill must be set towards the wind. In Western Europe, two methods have commonly been used to achieve this end. The earlier type of windmill is called a 'tower mill'. In this design, the top part of the structure, which holds the sails, can be turned to the wind. The disadvantage of this design is that the linkage which takes motion from the sails to the millstones in the base of the structure has to be made capable of accommodating the additional relative motion of the top piece. Overcoming this mechanical design problem proved to be more complicated than simply redesigning the whole structure. The apparently crude solution was the design known as a 'post mill', invented in the Netherlands in the fifteenth century. In a post mill, the whole mill — sails, linkage, millstones and all — turns about a huge vertical axle. The pictures listed here all show post mills.

Just as waterwheels have their equivalent today in the turbines used in hydro-electric plants, so (though more rarely) a modern version of the wind mill is now used on wind farms to generate electricity. However, such new windmills suffer from the same fundamental disadvantage as the windmills illustrated here: there is no getting away from the consequences of the fact that, per litre, moving water carries far more energy than moving air.

7.1 Jan van Goyen (1596 - 1656), *A Windmill by a river,* signed and dated 1642, 29.4 x 36.3 cm.

 Shows a post mill.

<div align="right">NG 2578.</div>

7.2 Jacob van Ruisdael (1628/9 - 1682), *Extensive landscape,* probably 1665 - 70, 109 x 146 cm.

 A windmill — a post mill — is neatly sketched, lit by a patch of sunlight, near the centre of the picture.

<div align="right">NG 990. ■ Plate, of whole + detail to show windmill</div>

7.3 Aelbert Cuyp (1620 - 1691), *A Milkmaid and Cattle near Dordrecht ('The large Dort'),* 157.5 x 197 cm.

 Includes fairly detailed depictions of windmills.

<div align="right">NG 961.</div>

7.2 Ruisdael (NG 990)

7.2 Ruisdael (NG 990, detail)

7.4 Aelbert Cuyp (1620 - 1691), *A Herdsman with Cattle near Dordrecht ('The small Dort'),* 66.4 x 100 cm.

Includes fairly detailed depictions of windmills.

NG 962.

7.5 Horace Vernet (1789 - 1863), *The Battle of Valmy,* signed and dated 1826, 174.6 x 287 cm.

The battle of Valmy, which took place on 20 September 1792, was a crucially important event in the early history of the French Revolution. At her request, Marie Antoinette's father, the Emperor of Austria, sent an army to crush the Revolution. The invaders met the 'ragamuffin' army of the new Republic at Valmy, and the Republican army won the battle. Louis XVI and some of his family attempted to flee the country, but were captured, put on trial, found guilty of treason, and guillotined.

The picture is one of a set of four paintings, showing famous French victories, commissioned from Vernet by the Duke of Orléans (later King Louis-Philippe, reigned 1830 - 1848). The Duke had led the defence of the mill shown in the picture. The mill is a post mill.

NG 2964.

8. Domestic and low technology

Domestic utensils and everyday items of furniture are shown in many of the pictures in the National Gallery. Here we have selected pictures that show ordinary items that either do not survive, or if they do are found in isolation from their spatial and social context. Indeed, since the individual items in museum collections may be difficult to date, pictures often provide very useful evidence. For instance, some early examples of fire irons are to be found in museum collections, but Giovanni di Paolo's picture *The Birth of St John the Baptist* (NG 5451) provides interesting additional information — showing us not only the type of fire irons used in Italy in the fifteenth century, but also how many such implements one might expect to find at a domestic fireside.

Here one must, however, exercise caution in interpreting apparently literal pictures. It is not possible to set a date for the beginning of historical consciousness, that is, the recognition that, in L. P. Hartley's phrase, 'The past is a foreign country: they do things differently there' (*The Go-between,* 1953, first words of Prologue). The emergence of such consciousness is usually associated with the Renaissance, in some form. A proper discussion of this question would necessitate wading deep into the swirling waters of history of ideas as well as history of art — though one may unreservedly recommend beginners to start with Ernst Gombrich's excellent *Art and Illusion* [Gombrich (1960)]. For our present purposes it is enough that, while painters such as Campin, Giovanni di Paolo and Antonello da Messina (had the question been put to them) might have said they knew very well that Christ, St John the Baptist and St Jerome had lived in times when domestic interiors and furnishings were very different from those found in the Netherlands or Italy in the fifteenth-century, these painters, and almost all their contemporaries, chose to show costumes and settings appropriate to their own place and time. On the other hand, Pinturicchio's picture of Penelope at her loom (NG 911) shows a mixture of fifteenth-century and 'ancient' things; and some painters of this time do show a considerable concern for historical accuracy in scenes that belong to the Ancient World. For instance there is much correct archaeological detail in paintings by Andrea Mantegna (1431 - 1506) — such as his *Agony in the Garden* (NG 1417, see section 5 above).

The later pictures in our list are mainly explicitly presented as showing scenes of everyday life (so-called 'genre' paintings) and thus do not pose the same kind of problem of interpretation. All the same, it is always well to remember that the painter's chief preoccupation is likely to be with his picture rather than with literal truth to appearances. For instance, the chances are that peasants and their homes were not always as clean and tidy as they were painted.

An addition to this list will be found in Section 11, which considers the floor mosaics by Boris Anrep (1885 - 1969).

8.1 Follower of Robert Campin (1378/9 - 1444), *Virgin and Child before a fire screen,* before 1430, 63.5 x 49.5 cm.

 The firescreen is woven from wickerwork. Its circular shape provides a suggestion of a halo for the Virgin.

 NG 2609.

8.2 Workshop of Robert Campin (1378/9 - 1444), *Virgin and Child in an interior,* probably 1420s, 18.7 x 11.6 cm.

 The scene includes a detailed depiction of a fireplace, with fire irons, towel rail and candle-holder.

<div align="center">NG 6514. ■ Plate, of whole</div>

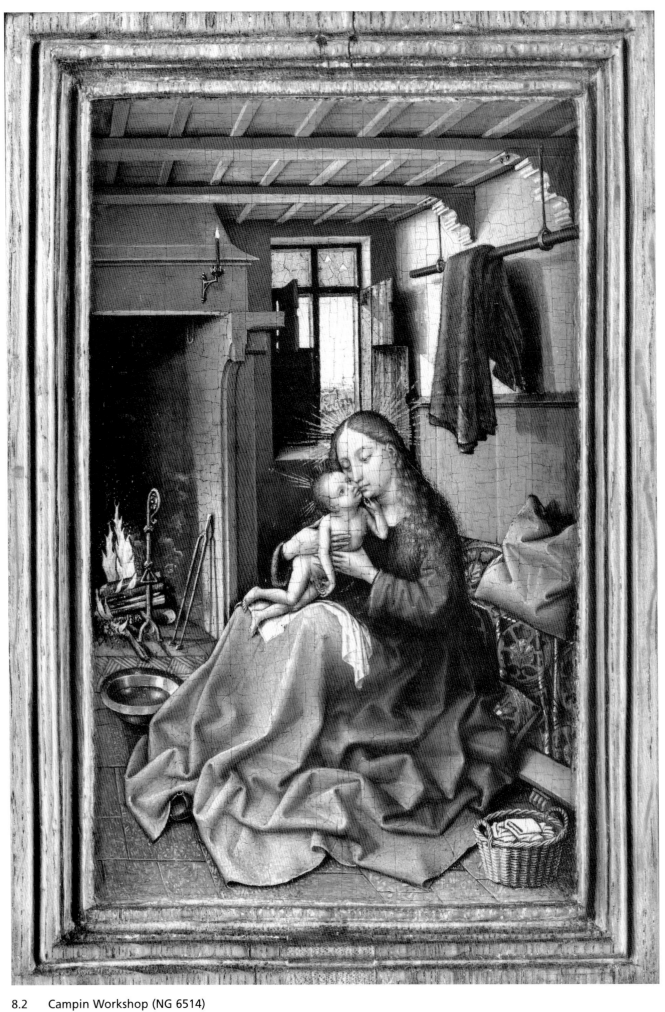

8.2　Campin Workshop (NG 6514)

8.3 Giovanni di Paolo (NG 5451)

8.3 Giovanni di Paolo (fl.1420 - 1482), *The Birth of St John the Baptist,*
 c. 1454, 30.8 x 44 .5 cm.

The scene includes a detailed depiction of a fireplace, with an array of fire irons
beside it. The interior shown is comfortable and spacious. One might perhaps not
expect to find such implements in poorer households.

NG 5451. ■ Plate, of whole

8.4 Antonello da Messina (c.1430 - 1479), *St Jerome in his study,* c. 1475,
 45.7 x 36.2 cm.

Shows a desk and writing implements with an array of domestic utensils on the
shelves behind it.

NG 1418.

8.5 Pinturicchio (Bernardino di Piero, c.1454 - 1513), *Penelope and the
 Suitors,* c.1509, 125.5 x 152 cm.

The picture illustrates a story told in the *Odyssey.* In the story as told by Homer,
Odysseus' wife, Penelope, had many suitors, who hoped that by marrying her they
could become ruler of Odysseus' kingdom. She had agreed with the suitors that she

8.5 Pinturicchio (NG 911)

must finish her piece of weaving, a shroud for Odysseus' father, before considering their proposals; and each night she unpicked what she had done that day, so as to gain time, since she still hoped that her husband would return — which he eventually did.

Here, Penelope is shown working at a loom, of a fifteenth-century design. However, her sandals are 'classical' (compare the fifteenth-century shoes of the servant sitting next to her) and the footwear of the suitor furthest to the right in the foreground also appears to have been inspired by that shown in Ancient sculpture. Odysseus' bow and quiver hang on the wall behind Penelope, and they too are of 'ancient' design. A full-rigged ship is visible through the window.

NG 911. ■ Plate, of whole

8.6 Hendrik Avercamp (1585 - 1634), *Scene on the ice near a town*, c. 1615, 58 x 89.8 cm.

The picture includes a simple crane, of a design that had been in use for several centuries.

NG 1479.

8.7 Saraceni (NG 6446)

8.7 Carlo Saraceni (1579 - 1620), *Moses defending the daughters of Jethro*, 1609 - 10, 28.5 x 35.3 cm.

Shows winding gear and pulley system at a well head. The complexity of the system seems rather excessive in context, but details of the apparatus are presumably correct — for the time the picture was painted.

NG 6446. ■ Plate, of whole

8.8 Valentin de Boulogne (c. 1591 - 1632), *The Four Ages of Man,* c. 1626 - 27, 96.5 x 134 cm.

The child is holding a bird trap.

NG 4919.

8.9 Philippe de Champaigne (1602 - 1674), *The Vision of St Joseph,* 208.9 x 155.6 cm.

Notably detailed and vivid rendering of carpentry tools. Most of these tools are of a design very similar to that of their modern counterparts. Indeed, many hand tools, such as various forms of hammer, have changed little since Ancient Roman times.

NG 6276. ■ Plate, of detail

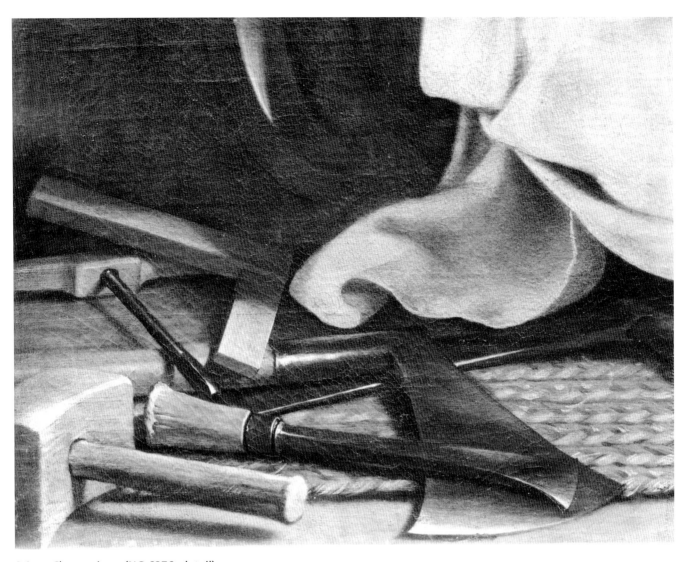

8.9 Champaigne (NG 6276, detail)

8.10 David Teniers the Younger (1610 - 1690), *A View of a Village with Three Peasants,* c. 1645, 112.5 x 166.7 cm.

Shows a rotating grindstone used for sharpening knives.

NG 950. ■ Plate, of whole

8.11 Abraham de Pape (1616 - 1666), *Tobit and Anna,* c. 1658, 40.7 x 56 cm.

Shows an old woman using a spinning wheel.

NG 1221.

8.12 Gerard Ter Borch the Younger (1617 - 1681), *An Officer dictating a letter,* c. 1655, 74.5 x 51 cm.

Shows a clay tobacco pipe. Tobacco had been introduced into Europe from the New World in the late sixteenth century. Smoking rapidly became fashionable, and for some time tobacco was believed to have medicinal properties.

NG 5847.

8.10 Teniers (NG 950)

8.13 Bartolomé Esteban Murillo (1617/8 - 1682), *Portrait of Dr Justino de Neve,* 1665, 206 x 129.5 cm.

The sitter is shown with an expensive modern table clock. He may have owned such a clock, and wished to show it off by having it included in his portrait, but it is also possible that the item is introduced as a symbol, perhaps referring to the fleeting nature of life (see also note on the portrait of Constantijn Huygens, entry 1.2 above, and the note on Holbein's *The Ambassadors,* entry 2.2 above).

NG 6448. ■ Plate, of detail

8.14 Attributed to Michiel Nouts (active 1656), *A Family Group,* 178 x 235 cm.

The child on the far right holds up a wooden doll, with brightly painted features.

NG 1699.

8.15 Arent Diepram (1622(?) - 1670(?)), *A Peasant smoking a pipe,* 28.5 x 23 cm.

Shows a clay tobacco pipe. There is a Rhenish stoneware jug in the foreground.

NG 3534.

8.13 Murillo (NG 6448, detail)

8.16 Jan Steen (1626 - 1679), *An Interior of an Inn, 'The Broken Eggs',* probably 1665 - 70, 43.3 x 38.1 cm.

The painting may well have some moral purpose connected with the broken eggs shown scattered in the right foreground, but it none the less gives a detailed picture of a frying pan. The handle is long and rises at a steep angle because the pan is for use on an open fire. At this period, it would have been usual for most cooking to be done over an open fire in a hearth in the kitchen. An oven was a relatively expensive item — and its design would have resembled that of the alchemist's furnace shown in the picture by Adriaen van Ostade (NG 846, see entry 2.4 above).

The kitchen range, in which the fire was enclosed, was introduced in the late eighteenth century, following the work of Count Rumford (Benjamin Thompson, 1753 - 1814). He had carried out a series of investigations of the amount of fuel used in particular household tasks and had concluded that the use of an enclosed fire was very much more economical.

NG 5637.

8.17 Pieter de Hooch (1629 - 1684), *A Woman and her Maid in a Courtyard,* 73.7 x 62.6 cm.

Domestic water supply, a pump, is shown in detail.

NG 794. ■ Plate, of whole

8.18 Nicolaes Maes (1634 - 1693), *A Girl rocking a Cradle,* c. 1654 - 59, 40.4 x 32.6 cm.

The cradle is made of wickerwork. There is a Rhenish stoneware flask on the table at the right.

NG 153.

8.19 Nicolaes Maes (1634 - 1693), *A Sleeping Maid and her Mistress ('The idle servant'),* signed and dated 1655, 70 x 53.5 cm.

The picture is probably intended to point a moral of some kind. It includes a notably detailed rendering of a wide variety of household crockery.

NG 207.

8.20 Godfried Schalken (1643 - 1706), *An Old Woman scouring a pot,* 1660s, 28.5 x 22.8 cm.

The woman is scouring a polished metal vessel. The number of standard symbols of mortality, such as a butterfly, an empty candleholder and a broken earthenware vessel, suggests that the picture is an allegory of transience (a type of picture called a 'vanitas').

NG 997.

8.17 Pieter de Hooch (NG 794)

8.21 Nicolas Lancret (1690 - 1743), *A Lady in a Garden taking Coffee with some Children,* 88.9 x 97.8 cm.

Shows a group of elegantly-dressed people near an elaborate ornamental fountain, which must have relied on the use of a pump (well hidden). Coffee was imported from Turkey. It became fashionable among the well-to-do from the 1680s onwards.

NG 6422.

8.22 William Hogarth (1697 - 1764), *The Graham Children,* 1742, 160.5 x 181 cm.

The portrait includes detailed representations of a clock and a musical box (as well as a classic portrayal of the interaction between a pet cat and a pet bird).

NG 4756.

8.23 Canaletto (Giovanni Antonio Canal, 1697 - 1768), *Venice, Campo San Vidal and Santa Maria della Carità,* probably late 1720s, 123.8 x 162.9 cm.

The picture shows a stonemason's yard, with unfinished workpieces and some tools.

NG 127.

8.24 Jean-Siméon Chardin (1699 - 1779), *Kitchen Scene (La Fontaine),* 1733, 37.5 x 44.5 cm.

Shows domestic water supply from an earthenware cistern fitted with a tap. Cisterns like this one allowed such obvious impurities as mud and gravel to sink to the bottom, so that clear water could be drawn off.

NG 1664. ■ Plate, of whole

8.25 Pompeo Batoni (1708 - 1787), *Time orders Old Age to destroy Beauty,* 1746, 135.3 x 96.5 cm.

The picture includes Time's standard attribute: a sand glass. Being cheap and convenient, sand glasses continued in use for a long time. Their most recent widespread application is to measure the three minutes allegedly required for boiling an egg.

NG 6316.

8.26 Luis Meléndez (1716 - 1780), *Still life with oranges and walnuts,* 1772, 61 x 81.3 cm.

The picture includes domestic food containers, apparently made of wood.

Reference: Jordan & Cherry (1995), Cat. no 58, pp. 160 - 161.

NG 6505. ■ Plate, of whole

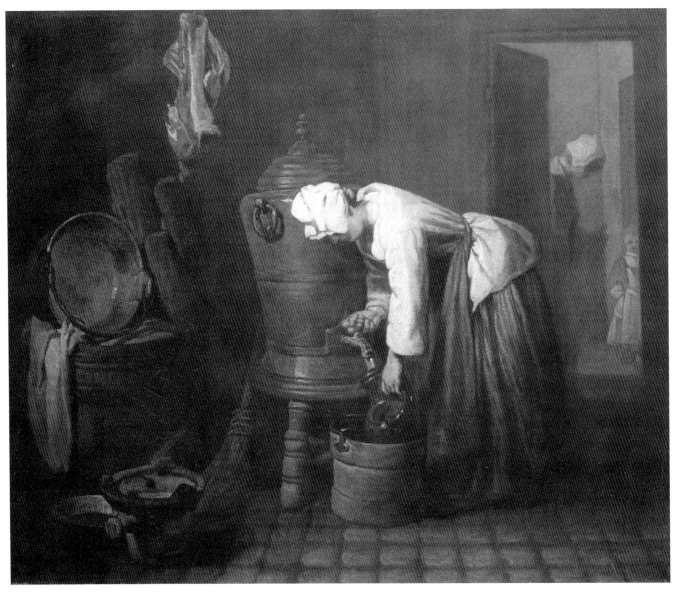

8.24 Chardin (NG 1664)

8.27 Imitator of Chardin, *Still Life with Bottle Glass and Loaf,* probably nineteenth century, 38.1 x 45.1 cm.

Shows wine bottle, stemless wine glass and bread knife.

NG 1258.

8.28 John Constable (1776 - 1837), The Cornfield, 1826, 142 x 121.9 cm.

Includes a plough, which is presumably ready for use once reaping is completed.

NG 130.

8.29 Philippe Rousseau (1816 - 1887), *Still Life with Oysters,* probably, 1875 - 87, 42.2 x 62.2 cm.

Shows large wine bottle and a conical drinking glass with a stem.

NG 3829.

8.30 Camille Pissarro (1830 - 1903), *Boulevard Montparnasse,* 1897.

Street lighting. See under 'New technology of the nineteenth century', entry 10.5 below.

NG 4119.

8.26 Meléndez (NG 6505)

8.31 **Paul Cézanne (1839 - 1906), A Stove in the Studio, late 1860s,
41 x 30 cm.**

Stoves like this were a usual form of domestic heating. Cézanne's family was rich,
but in the 1860s his father kept him on a small allowance, and the studio shows no
signs of luxury.

The first owner of this picture was Cézanne's former school fellow, the writer Émile
Zola (1840 - 1902).

NG 6509. ■ Plate, of whole

8.31 Cézanne (NG 6509)

9. Transport

We have included in this section illustrations of vehicles, such as boats, and engineering structures such as bridges. We have also included several pictures that show rivers being crossed by means of a ford rather than a bridge. Pictures have been chosen for giving a relatively detailed rendering of the things concerned, thus excluding, for instance, pictures by Claude Lorrain (1600 - 1682) that show ships in the distance against shimmering sunlight. Moreover, we have not attempted to illustrate the history of roads. It will be noted that most of the roads shown are, in fact, rutted tracks, whose condition depended upon the weather. It was not until the late eighteenth century that it became usual to give roads a smooth surface that allowed water to run off it. This kind of surface is called 'macadam' after its inventor John Loudon McAdam (1756 - 1836).

Until the nineteenth century, bridges were regarded merely as a specialised kind of building. There were local traditions for their method and style of construction. With the coming of the railways, engineers such as Isambard Kingdom Brunel (1806 - 1859) and Robert Stephenson (1803 - 1859) turned their attention to bridges, and produced over-engineered — but long-lasting — solutions to the problems they presented. Practical experience led to structures that were closer to the presumed theoretical limit. Ideas were drastically revised after the spectacular collapse of the Tay Bridge, with the loss of an estimated 75 lives, in storm-force winds, in 1879. Over-engineering of bridges has been in fashion ever since.

We have omitted the large number of pictures that show the commonest means of transport (apart, that is, from merely walking): the horse. In Europe, horses have been ridden, and harnessed, since at least the first millennium BC. However, early wheeled vehicles were used, by the rich, as a relatively comfortable means of transport, not as a relatively rapid one. In fact, water transport, using rivers or canals, was generally faster than road transport until the end of the eighteenth century. When, in the mid seventeenth century, Samuel Pepys (1633 - 1703) wanted to get to Greenwich quickly, he travelled there by boat down the Thames, as indeed did Michael Faraday in the 1830s. Land transport came into its own with the introduction of the railways, beginning in the 1840s. From the 1750s until the 1840s, most transport of goods took place by boat, either along the coast or inland along canals. In Britain, gentry, bankers and, later, industrialists such as Josiah Wedgwood (1730 - 1795), invested huge amounts of money in constructing canals and their associated systems of locks, pumping stations and viaducts. (The workmen who constructed the canals were called 'navigators', hence the word 'navvy'.) However, on account of its collecting policy, no trace of this activity can be seen in the pictures in the National Gallery. Many British artists painted canals, though it should be pointed out that Turner's famous *Chichester Canal,* versions in the Tate Gallery (London) and at Petworth House (Sussex), shows a military canal, not a commercial one. While one might plead that canals themselves, being no more than tidy waterways, do not offer huge pictorial possibilities, the same can hardly be claimed for pumping stations, locks and, particularly, viaducts. Painters no doubt correctly estimated the taste of their customers and patrons in avoiding such subjects. There seems to have been a tacit agreement that they were not suitable for pictures.

Despite the absence of pictures of canals from the period of their greatest economic importance, water transport does in fact dominate in the list of pictures that follows. What the pictures tend to show is the variety of different boats used in different waters. For instance, the shallow-draft punt, propelled by a pole, was appropriate for crossing the Thames at Eton (see Canaletto's picture, NG 942, entry 9.16 below).

In certain categories, most notably for waterwheels, the Gallery's collection seemed to underestimate the importance of such things for society as a whole. However, in the case of transport (apart from the omission of canals noted above) the collection seems to provide a much fairer account of the matter. This may be because journeys were nearly always in principle

something out of the ordinary, and thus had an interest which found its expression in pictures. Journeys in fact also have a large place in literature: from Homer's *Odyssey* to Douglas Adams's *Hitch-hiker's Guide to the Galaxy,* via a large number of eighteenth-century novels.

9.1 Rogier van der Weyden (1399 - 1464), *St Ivo (?),* c. 1450, 45.1 x 34.8 cm.

The background landscape includes a road bridge, and detailed reflections in the river under it.

NG 6394. ■ Plate, of detail

9.2 Follower of Fra Angelico (c.1400 - 1455), *The Rape of Helen,* 50.8 x 61 cm.

The story, taken from Homer's *Iliad,* is that of the incident which led to the Trojan War: Paris, a son of King Priam of Troy, is carrying off Helen, the wife of Menelaus, King of Sparta. Some elements in the architecture are drawn from Ancient sources, and the small statue on the column in the background is clearly meant to represent one of the pagan gods. However, the ship, whose stern can be seen in some detail, is apparently of fifteenth-century design. Compare with that shown in another scene derived from Homer, Pinturicchio's picture of Penelope and the suitors (NG 911, see entry 8.5 above).

NG 591.

9.3 Hans Memling (c.1430/40 - 1494), *The Donne Triptych.*

Bridge. See under 'Mirrors', entry 3.4 above.

NG 6275.

9.4 Francesco Botticini (?) (Francesco di Giovanni, c.1446 - 1497), *Assumption of the Virgin.*

Bridge. See under 'Mirrors', entry 3.7 above.

NG 1126.

9.5 Albrecht Altdorfer (before 1480 - 1528), *Landscape with a footbridge,* 1518 -20, 41.2 x 35.5 cm.

This picture is a rare example from this period of a landscape painting that does not include figures. It shows a high wooden footbridge across a river.

NG 6320. ■ Plate, of whole

9.6 Peter Paul Rubens (1577 - 1640), *An Autumn landscape with a view of Het Steen in the Early Morning,* late 1630s, 131.2 x 229.2 cm.

Rubens had bought the estate of Het Steen in 1635. On the left there is a farm cart carrying a trussed calf that is presumably being taken to market.

NG 66.

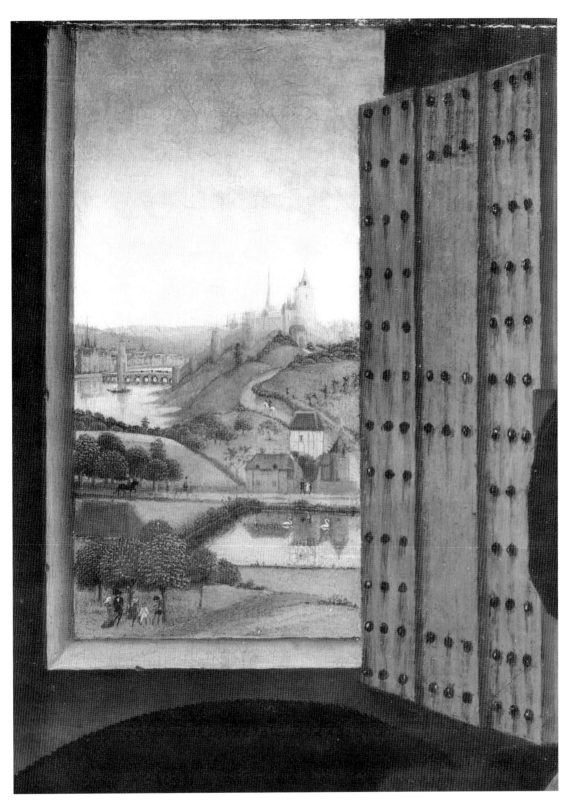

9.1 Rogier van der Weyden (NG 6394, detail)

9.7 Domenichino (Domenico Zampieri, 1581 - 1641) and assistants, *The Flaying of Marsyas,* before 1616, 210.2 x 331.4 cm.

The story is taken from classical mythology. Marsyas set himself up as a rival to Apollo in making music. Apollo won the ensuing contest, and Marsyas was flayed as a punishment for his presumption.

The background to Domenichino's fresco includes a bridge, which may be intended to be of Ancient design.

NG 6288.

9.5 Altdorfer (NG 6320)

9.8 Isaak van Ostade (NG 963)

9.8 Isaak van Ostade (1621 - 1649), *Winter scene,* 1640s, 48.8 x 40 cm.

Shows a sledge being used to cross a river.

NG 963. ■ Plate, of whole

9.9 Carel Fabritius (1622 - 1654), *View of Delft,* dated 1652.

Shows a canal with a bridge. See under 'Scientific information', entry 4.10 above.

NG 3714.

9.10 Jan van de Cappelle (1626 - 1679), *River scene with a Large Ferry,* mid 1660s, 122 x 154.5 cm.

Shows transport of cannon by a ferry. The long and bitter war against Spanish domination of the Netherlands ended in 1648.

NG 967.

9.11 Jacob van Ruisdael (1628/9 1682), *A Waterfall,* probably 1660s, 98.5 x 85 cm.

There is a wooden footbridge over the weir in the background. The painter has made a contrast between the rather orderly flow of water over the weir and the turbulence of the natural waterfall.

NG 627.

9.12 Velde (NG 978)

9.12 **Willem van der Velde the Younger (1632 - 1767),** *A Dutch Yacht,*
 surrounded by Many Small Vessels, saluting as Two Barges pull
 alongside, 1661, 90 x 126 cm.

Notable for detailed portrayal of sailing ships, including a warship (compare Turner's
Fighting Temeraire, see entry 10.1 below).

NG 978. ■ Plate, of whole

9.13 **Meindert Hobbema (1638 - 1709),** *A View of the Haarlem lock and the*
 Herring-Packers' Tower, Amsterdam, 77 x 98 cm.

Shows a canal with a lock and a movable bridge.

NG 6138. ■ Plate, of whole

9.14 **Canaletto (Giovanni Antonio Canal, 1697 - 1768),** *Venice, upper reaches*
 of the Grand Canal with San Simeone Piccolo, c. 1738, 124.5 x 204.6 cm.

Detailed depictions of gondolas. It should be remembered that, at the time Canaletto was
painting, the easiest way to get about many cities was by water. Venice began to look
strange in its reliance upon water transport only with the development of more conve-
nient and rapid land transport, from the second half of the eighteenth century onwards.

NG 163.

9.13 Hobbema (NG 6138)

9.15 Canaletto (Giovanni Antonio Canal, 1697 - 1768), *Venice, Doge's Palace and the Riva degli Schiavoni,* probably late 1730s, 61.3 x 99.8 cm.

Shows a variety of shipping at a busy mooring place.

NG 940.

9.16 Canaletto (Giovanni Antonio Canal, 1697 - 1768), *Eton College,* c. 1754, 61.6 x 107.7 cm.

A punt is shown acting as a ferry across the Thames.

NG 942.

9.17 Francesco Guardi (1712 - 1793), *Venice, Punta della Dogana with Santa Maria della Salute,* c. 1770, 56.2 x 75.9 cm.

Shows a variety of shipping.

NG 2098.

9.18 Francesco Guardi (1712 - 1793), *Venice, the Arsenal,* 1755 - 60, 62.3 x 96.9 cm.

The Arsenal was the military workshop and naval dockyard of the Republic of Venice. Guardi has shown the entrance to the Arsenal through the short canal from the Basin of St Mark (there is an entrance directly from the Lagoon, with a similar pair of towers, on the opposite side). The walls and towers do not look like serious defences

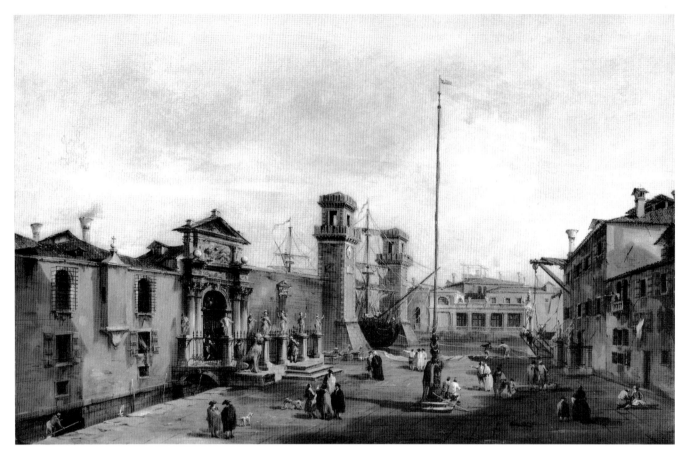

9.18 Francesco Guardi (NG 3538)

because no enemy ship was expected ever to get this far — and none did. The classical portico to the left of the gate was built in the 1460s, and is the earliest example of Albertian Renaissance architecture in Venice. Sculptured decoration was added to it later, and an inscription made it into a memorial to the naval commanders who fought, and won, at the battle of Lepanto in 1571. (The battle was against a Turkish fleet. Lepanto is in the Gulf of Itea, an inlet on the North side of the Gulf of Corinth, in Greece. The battle marked the end of the Turks' gradual push Westwards immediately after their capture of Constantinople in 1453.)

A sailing ship is emerging from the gate of the Arsenal, and on the right one can see a drawbridge being raised to allow the ship through into the canal. By the time this picture was painted Venice was no longer an important naval power in world terms. Her wealth and her political power began to decline with the Portuguese discovery of the sea route to India at the end of the fifteenth century (before that, Venice had more or less enjoyed a monopoly on trade with the East). However, the decline was slow, and in the sixteenth century the Arsenal was one of the most advanced technical and engineering establishments in Europe. Galileo Galilei, who taught mathematics at the University of Padua from 1592 to 1610, claimed to have learned much from the practical know-how of the artisans in the Arsenal. (Padua was only about a half-day's journey from the city of Venice — by water, along the Brenta canal — and its university, founded in 1202, was effectively the university of the Venetian Republic.)

NG 3538. ■ Plate, of whole

9.19 Claude-Joseph Vernet (1714 - 1789), *A sporting contest on the River Tiber at Rome,* signed and dated 1750, 99.1 x 135.9 cm.

Includes a detailed rendering of various small boats and of the bridge beside the Castle Sant' Angelo (Ponte Sant' Angelo).

NG 236. Room G.

9.20 Vernet (NG 201)

9.20 Claude-Joseph Vernet (1714 - 1789), *A Sea Shore,* 62.2 x 85.1 cm.

The scene is imaginary, but appears to be inspired by pictures of the Italian coast. It shows sea defences and a lighthouse.

NG 201. ■ Plate, of whole

9.21 Attributed to Claude-Joseph Vernet (1714 - 1789), *A Seaport,* after 1750, 97.2 x 134 cm.

The scene may be intended to represent Marseille or Toulon. It shows sea defences and a lighthouse.

NG 1393.

9.22 Thomas Gainsborough (1727 - 1788), *The Market Cart,* 84 x 71.5 cm.

A farm cart is shown laden with produce on its way to market. A woman and child, presumably members of the farmer's family, are riding with the load. The cart is in the process of being pulled across a ford.

For comments on Gainsborough, see the entry for his Portrait of Dr Schomberg, item 1.5 above.

NG 80.

9.23 J. A. Vallin (1760 - 1835), *Portrait of Dr Forlenze,* 1807.

Includes a lighthouse, possibly one at Naples. See entry 1.6 above.

NG 2288.

9.24 John Constable (1776 - 1837), *Stratford Mill.*

There is a barge passing on the waterway. See under 'Waterwheels', entry 6.7 above.

NG 6510.

9.25 J. M. W. Turner (1775 - 1851), *The Fighting Temeraire.* 1838.

Ships. See under 'New technology of the nineteenth century', entry 10.1 below.

NG 524..

9.26 J. M. W. Turner (1775 - 1851), *Rain, steam and speed.*

Railway train. See under 'New technology of the nineteenth century', entry 10.2 below.

NG 538.

9.27 John Constable (1776 - 1837), *The Haywain,* signed and dated on back 1821, 130.2 x 185.4 cm.

Together with his signature, Constable has noted that the picture was painted in London. The scene is based on landscape in Suffolk, near Flatford on the river Stour. The picture shows an unloaded cart being pulled across a ford. The number of horses being used shows that the cart will eventually carry a heavy load. Hay makers can be seen across the meadow on the right.

NG 1207.

9.28 John Constable (1776 - 1837), *Salisbury Cathedral.*

Shows a farm cart. See under 'Meteorological phenomena', entry 5.7 above.

L.47

9.29 Eduard Gaertner (1801 - 1873), *Friedrichsgracht, Berlin,* 1858 - 60, 25.5 x 44.6 cm.

Portrait of a dock.

NG 6524. ■ Plate, of whole

9.30 Christen Købke (1810 - 1848), *The Northern Drawbridge to the Citadel at Copenhagen.*

Bridge. See under 'New technology of the nineteenth century', entry 10.3 below.

NG 6507.

9.29 Gaertner (NG 6524)

9.31 Charles-François Daubigny (1817 - 1878), *St Paul's from the Surrey side.*

Steamboats. See under 'New technology of the nineteenth century', entry 10.4 below.

NG 2876.

9.32 Camille Pissarro (1830 - 1903), *Boulevard Montparnasse.*

Street lighting. See under 'New technology of the nineteenth century', entry 10.5 below.

NG 4119.

9.33 Claude Monet (1840 - 1926), *Bathers at La Grenouillière,* signed and dated 1869, 73 x 92 cm.

Shows rowing boats to be used for recreation.

NG 6456.

9.34 Claude Monet (1840 - 1926), *The Thames below Westminster,* 1871

Steamboats and the Victoria Embankment. See under 'New technology of the nineteenth century', entry 10.6 below.

NG 6399.

9.35 Claude Monet (1840 - 1926), *Gare St Lazare,* 1877.

Railway engines and architecture. See under 'New technology of the nineteenth century', entry 10.7 below.

NG 6479.

9.36 Georges Seurat (1859 - 1891), *Bathers at Asnières,* 201 x 300 cm.

A railway bridge and smoking factory chimneys can be seen in the background.

NG 3908.

10. New technology of the nineteenth century

The stationary steam engine was invented by Thomas Newcomen (1663 - 1729) in the early eighteenth century, and greatly improved by James Watt (1736 - 1819) in the 1760s. It was widely employed in areas where other sources of power were difficult to exploit. One such area was Cornwall, in the West of England, where steam-driven machinery was used to pump water out of tin mines. These engines worked at close to atmospheric pressure. The first practical high-pressure steam engine was invented by Richard Trevithick (1771 - 1833) at the beginning of the nineteenth century. Developed versions of this engine were soon used to supply power for railway locomotives and ships. Although such engines are usually described as driven by steam, the motive power being used is in fact the heat produced from the burning of coal. Newcomen did indeed call his invention 'an engine for raising water by the impellant force of fire'.

The rapid industrialisation with which steam power was associated began in the second half of the eighteenth century, specifically in Britain. One important factor in this development was the easy availability of coal in Britain — in the North East of England and in the Midlands. The Industrial Revolution caused huge changes in the lives of almost everyone. (Moreover, although most of the machinery was powered by waterwheels, the Industrial Revolution is characterised by the beginnings of a turning away from the renewable resources of water and wind, and the adoption of the use of fossil fuels — a change whose consequences for the natural environment are now beginning to be recognised as very important.) At the time, artists probably reflected public opinion — at least among the educated classes — in seeing something romantic and inspiring in the exercise of new-found power. The painting of an iron works, *Coalbrookdale by Night,* by Philippe de Loutherbourg (1740 - 1812), now in the Science Museum, London, reminds one vividly that he was a designer of stage scenery, and is very much in the style of contemporary pictures of volcanoes in eruption. Pictures of machinery in action frequently belong to the world of the picturesque rather than being notable for their technical accuracy. Some good examples of such pictures were shown in the Wright of Derby exhibition at the Tate Gallery (London) in 1990 (see Egerton (1990), and Klingender (1968)). The two paintings by J. M. W. Turner (1775 - 1851) which we have included here are good examples of his characteristic use of dramatic events as a source of visual inspiration. Neither is necessarily to be read as a hymn of praise to the new technology it shows in action.

However, the exhilaration of Turner's *Rain, Steam and Speed* (NG 538) finds a counterpart in works by a later generation of artists, who generally found his work too romantic for their taste. In particular, the series of pictures of Gare St Lazare (Paris) by Claude Monet (1840 - 1926), one of which is in the National Gallery (NG 6479), shows immense enjoyment of the spectacle provided by locomotives at work.

In our own century, electric power has replaced steam as the characteristic technology driving new developments. Like the use of steam, modern electricity also has its origins in the eighteenth century, when Alessandro Volta (1745 - 1827) constructed the first apparatus capable of producing a continuous supply of electric current. The principles of the three devices on which modern electrical machinery depends were all discovered by Michael Faraday (1791 - 1867): that of the electric motor in 1821, and those of the transformer and the dynamo in 1831. Practical devices using these principles were developed towards the end of the nineteenth century. This is an early example of the now standard phenomenon of scientific understanding leading technological development. The older pattern, in which technology developed essentially separately (and was often in advance of scientific understanding), is well seen in the story of steam power: working engines were in use more than a century before the development of the theory of thermodynamics.

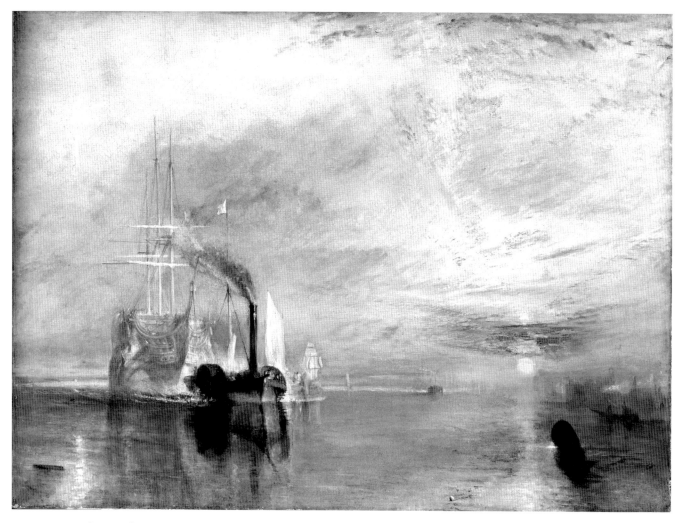

10.1 Turner (NG 524)

Some twentieth-century examples will be found in the next section, Section 11, which considers the floor mosaics by Boris Anrep (1885 - 1969).

10.1 J. M. W. Turner (1775 - 1851), *The Fighting Temeraire,* dated 1838, 90.8 x 121.9 cm.

The Temeraire was launched in 1798, and fought with distinction at the Battle of Trafalgar (1805), after which she was known as the Fighting Temeraire. The scene shown here is that of the warship being towed to Rotherhithe to be broken up. A steam tug is shown pulling a sailing ship. However, the elegiac quality of the painting is almost certainly not an expression of regret that a new technology is superseding the old: steamships were not new, and Turner painted many pictures that show his enjoyment of the spectacle they provided (together with their plumes of smoke). It was the usual fate of ships to be broken up once they had become obsolete, but for some reason Turner found this particular example specially moving, perhaps because of the heroic record of the vessel concerned. His picture is an imaginative reconstruction, notably inaccurate in a number of respects: for instance, the Temeraire had certainly been dismasted before she was handed over to the shipbreaker. The picture was probably based on newspaper reports. There is no evidence Turner actually witnessed the event concerned.

A thorough discussion of this picture, and its historical context, is given in Egerton (1995).

NG 524. ■ Plate, of whole

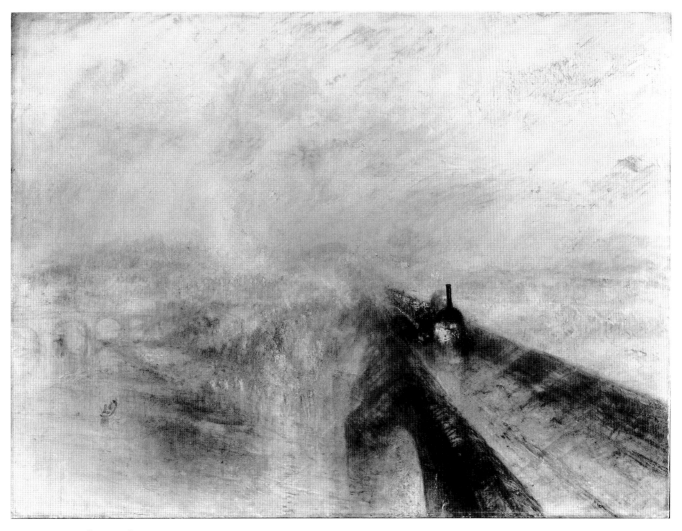

10.2 Turner (NG 538)

10.2 J. M. W. Turner (1775 - 1851), *Rain, steam and speed*, 1838 - 1844,
 90.8 x 121.9 cm.

An enthusiastic picture of a railway train — Great Western, broad gauge — travelling
at speed over a bridge near Maidenhead. Turner had travelled on this line, which was
opened in 1837. The picture is not an exact topographical study: the road bridge is
shown as it would be seen from the train.

NG 538. ■ Plate, of whole

10.3 Christen Købke (1810 - 1848), *The Northern Drawbridge to the Citadel
 at Copenhagen*, 1837, 44.2 x 65.1 cm.

A bridge that can be raised to allow passage for ships.

NG 6507. ■ Plate, of whole

10.4 Charles-François Daubigny (1817 - 1878), *St Paul's from the Surrey side*,
 1873, 44 x 81.3 cm.

Shows steamboats on the Thames.

NG 2876.

10.3 Købke (NG 6507)

10.5 Camille Pissarro (1830 - 1903), *Boulevard Montparnasse,* 1897, 53.3 x 64.8 cm.

Shows street lighting. Street lighting was introduced in the first decade of the nine-teenth century. At first it was by gas: gas lighting was installed in Pall Mall, London, in 1807. The development of more reliable electric generators in the 1860s allowed the installation of electric street lighting, first using electric arc lights and then using incandescent lamps. However, gaslight continued to be used, and was greatly improved by the introduction of the gas mantle in 1893. (The mantle was an open-work cover that fitted over the gas jet and became incandescent when heated by the flame.) Electric lighting had been used in Paris for twenty years when Pissarro painted this picture: electric arc lights had been installed in the Avenue de l'Opéra in 1877. Thus neither street lighting itself, nor the technology used for it, was a novelty at the time this picture was painted. Pissarro had decided to copy the example set by Monet in painting series of pictures of the same scene at different times of day, and one of the scenes he chose was a view of the Boulevard Montparnasse.

NG 4119. ■ Plate, of whole

10.6 Claude Monet (1840 - 1926), *The Thames below Westminster,* 1871, 47 x 72.5 cm.

Shows steamboats on the river, and the Victoria Embankment, which was then new.

NG 6399. ■ Plate, of whole

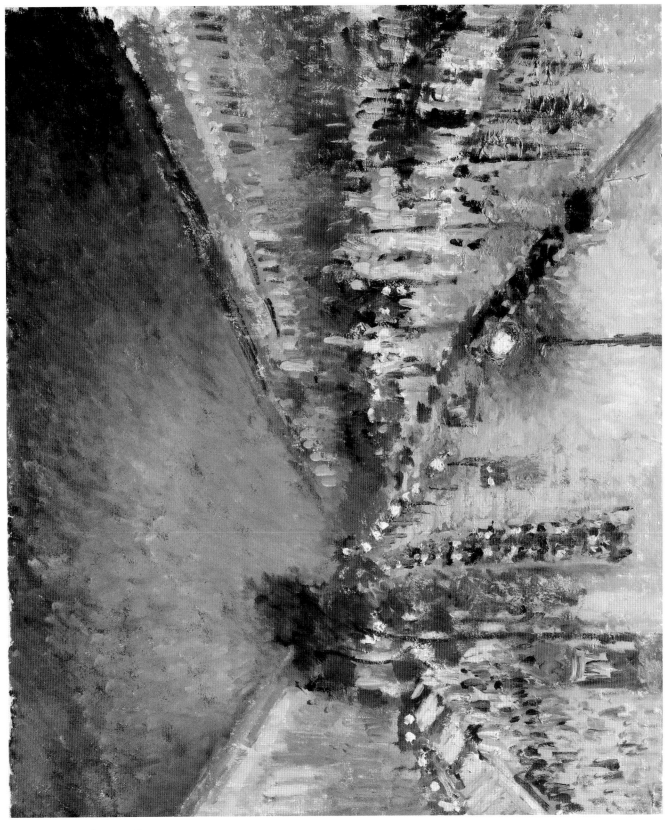

10.5 Pissarro (NG 4119)

10.6 Monet (NG 6399)

10.7 Claude Monet (1840 - 1926), *Gare St Lazare,* 1877, 54.3 x 73.6 cm.

An enthusiastic picture of railway engines and station architecture. The station authorities, under a misapprehension as to Monet's current standing rather than in anticipation of his later fame, afforded him every facility in his work, running engines in and out as he wished, and causing them to emit more steam on request.

Monet's interest is in making a static picture, showing (for instance) the effects of light in the puffs of steam, whereas Turner (10.2) had been concerned to show the rushing speed of a train in motion.

NG 6479. ■ Plate, of whole

10.8 Georges Seurat (1859 - 1891), *The Rainbow* (a study for *Bathers at Asnières).*

Includes a factory at Asnières. See under 'Meteorological phenomena', entry 5.9 above.

NG 6555.

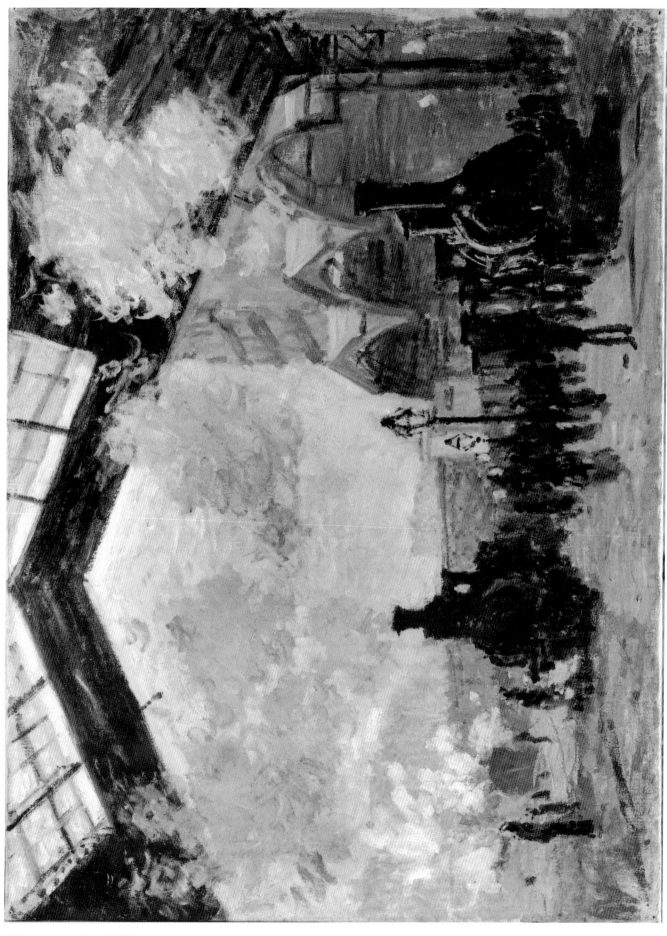

10.7 Monet (NG 6479)

11. Boris Anrep's floor mosaics (1928, 1929, 1933, 1952)

Four areas of floor on the landings of the stairway leading up from the main entrance of the National Gallery are decorated with mosaics by Boris Anrep (1885 - 1969). Each area has a separate programme.

The half-way landing, opened in 1933, shows 'The Awakening of the Muses'. Anrep made the muses portraits of contemporaries, but was apparently unable to find a female professional astronomer for Urania. Contemporary portraits are also included in the floor of the North Vestibule, completed in 1952, which shows 'The modern virtues'. 'Curiosity' is personified in Ernest Rutherford, 'Lucidity' in Bertrand Russell, and 'Pursuit' in Fred Hoyle. The remaining mosaics, 'The Labours of Life' (1928) in the West Vestibule and 'The Pleasures of Life' (1929) in the East Vestibule, show genre scenes, which include various items of 1920s scientific tools and equipment. The nature of mosaic precludes showing detail, but the choice of impressive equipment, such as an electric drill, is an interesting indication of attitudes of the time.

Fuller descriptions of the mosaics, and a detailed plan, are given in a leaflet, National Gallery (1993).

Portraits etc.

11.1 *Urania,* 1933, mosaic on half-way landing (back right).

> The set of mosaics on this landing shows 'The Awakening of the Muses'. Urania is the Muse of Astronomy. For some of the Muses Anrep made portraits of suitable sitters. For instance, the Muse of Tragedy (Melpomene) is a portrait of the film star Greta Garbo. Presumably for lack of suitable female astronomers, Urania is a portrait of the artist's sister-in-law.

11.2 *Curiosity,* 1952, mosaic on the floor of the North Vestibule (straight ahead from entrance), in front of the door on the right.

> The mosaics in this area show 'The Modern Virtues'. *Curiosity* shows a portrait bust of the physicist Ernest Rutherford (Lord Rutherford, 1871 - 1937), together with an image that represents his most famous scientific achievement, 'splitting the atom'. This advance in scientific understanding eventually had huge technological consequences, among them nuclear weapons and nuclear power stations.

> ■ Plate, of whole

11.3 *Lucidity,* 1952, mosaic on the floor of the North Vestibule (straight ahead from entrance), in front of the door on the left.

> The mosaics in this area show 'The Modern Virtues'. *Lucidity* is a portrait of the philosopher and mathematician Bertrand Russell (1872 - 1970).

11.2 Anrep *(Curiosity)*

11.4 *Pursuit,* 1952, mosaic on the floor of the North Vestibule (straight ahead from entrance), in the near right corner as one comes up the stairs.

The mosaics in this area show 'The Modern Virtues'. *Pursuit* shows a steeplejack, who is a portrait of the astronomer and writer of science fiction Professor Fred Hoyle (b.1915, FRS 1957, knighted 1972).

■ Plate, of whole

Scientific impedimenta or activity

11.5 *Astronomy,* 1928, mosaic on the floor of the West Vestibule (to the left from entrance), ahead right as one comes up the stairs.

The mosaics in this area show 'The Labours of Life'. Astronomy gives a rather diagrammatic picture of a large reflecting telescope in use.

11.6 *Science,* 1928, mosaic on the floor of the West Vestibule (to the left from entrance), ahead left as one comes up the stairs.

The mosaics in this area show 'The Labours of Life'. *Science* shows a man studying prehistoric animals in the British Museum (Natural History) (now called the Natural History Museum).

Domestic and low technology

11.7 *Commerce,* 1928, mosaic on the floor of the West Vestibule (to the left from entrance), sharp left as one comes up the stairs.

The mosaics in this area show 'The Labours of Life'. *Commerce* shows a Covent Garden porter carrying a pile of cylindrical baskets of fruit and vegetables.

The Covent Garden Market moved to a new site at Nine Elms, south of the river Thames, in 1973.

Newer technology

11.8 *Engineering,* 1928, mosaic on the floor of the West Vestibule (to the left from entrance), sharp left as one comes up the stairs.

The mosaics in this area show 'The Labours of Life'. *Engineering* shows a man using an electric drill.

11.9 *Mining,* 1928, mosaic on the floor of the West Vestibule (to the left from entrance), far left corner as one comes up the stairs.

The mosaics in this area show 'The Labours of Life'. *Mining* shows a coal miner (collier) at work.

■ Plate, of whole

11.4 Anrep *(Pursuit)*

11.9 Anrep *(Mining)*

BIBLIOGRAPHY

Alpers (1983): Svetlana Alpers, *The Art of Describing: Dutch Art in the seventeenth century,* Chicago, 1983

Baltrušaitis (1977): J. Baltrušaitis, *Anamorphic Art,* Cambridge, 1977 (expanded translation of a French original).

Braham (1976): Allan Braham, *Velázquez: The Rokeby Venus, Painting in Focus,* Number 5, London: The National Gallery, 1976.

Chapuis (1944): Alfred Chapuis, *De Horologiis in Arte: L' Horloge et le montre à travers les ages, d' après les documents du temps,* Lausanne, 1944.

Clarke (1986): T. H. Clarke, *The Rhinosceros, from Dürer to Stubbs,* London: Sotheby, 1986.

Edgerton (1991): S.Y. Edgerton, *The Heritage of Giotto's Geometry,* Ithaca and London, 1991.

Egerton (1990): Judy Egerton, *Wright of Derby* [exhibition catalogue], London: Tate Gallery, 1990.

Egerton (1995): Judy Egerton, *Turner. The Fighting Temeraire* [exhibition catalogue, with a technical examination of the painting by M. Wild and A. Roy], London: National Gallery Publications, 1995.

Field (1988): J. V. Field, 'What is scientific about a scientific instrument?', *Nuncius,* **3**.2 (1988), 3-26.

Field (1997): J. V. Field, *The Invention of Infinity: Mathematics and Art in the Renaissance,* Oxford (1997).

Field (forthcoming): J. V. Field, 'Mathematical books in the library of Diego Velázquez (1599 - 1660)' (forthcoming).

Field & Gray (1987): J.V. Field and J.J. Gray, *The Geometrical Work of Girard Desargues,* New York, 1987.

French, Palmer & Wright (1985): A. French, F. Palmer, and M. T. Wright, *Joseph Merlin the Ingenious Mechanick,* 1735 - 1803 [exhibition catalogue, Iveagh Bequest, Kenwood House], London: Greater London Council, 1985.

Gombrich (1960): E. H. Gombrich, *Art and Illusion,* London, 1960, fifth edition 1977, many reprints.

Gombrich (1995): E. H. Gombrich, *Shadows: the depiction of cast shadows in Western Art,* London: National Gallery Publications, 1995.

Hill (1993): C. R. Hill, 'Scientific instruments: an iconographic note', in R. G. W. Anderson, J. A. Bennett and W. F. Ryan (eds), *Making Instruments Count,* Aldershot, 1993, 88 - 98.

Hills (1987): Paul Hills, *The Light of Early Italian Painting,* London & New Haven, 1987.

House (1980): John House, 'Meaning in Seurat's figure paintings', *Art History,* **3** (1980) 341 - 356.

Jordan & Cherry (1995): William B. Jordan and Peter Cherry, Spanish Still Life from Velázquez to Goya [exhibition catalogue], London: National Gallery Publications, 1995.

Kemp (1984): M. J. Kemp, 'Construction and Cunning: the perspective of the Edinburgh Saenredam', in Macandrew, Hugh (ed.), *Dutch Church Painters: Saenredam's 'Great Church at Haarlem' in context* [Exhibition catalogue], Edinburgh: National Gallery of Scotland, 1984.

Kemp (1990): M.J. Kemp, *The Science of Art: Optical themes in Western art from Brunelleschi to Seurat,* New Haven and London, 1990.

Klingender (1968): F. D. Klingender, *Art and the Industrial Revolution,* London, 1947, second edition ed. A. H. R. Elton, London, 1968, reprinted 1972, 1991.

National Gallery (1993): *An Introduction to Boris Anrep's mosaics at the National Gallery, London,* London: National Gallery Publications, 1993.

Sanchez Cantón (1925): F. J. Sanchez Cantón, 'La librería de Velázquez', in *Homenaje ofrecido a Menéndez Pidal,* vol. 3, Madrid, 1925, pp. 379 - 406.

INDEX OF ARTISTS

This index is for paintings by the given artist. When artists are mentioned in introductory material or in entries referring to paintings by others, the name will be found in the General Index.

Numbers refer to entries. Numbers of subsidiary entries for the same picture are given in [].

GENERAL INDEX

Reference is generally to the numbers of particular entries, introductory material being designated by .0 (so the reference 8.0 indicates the introduction to section 8). The very long entry for item 2.2 (Holbein, The Ambassadors) has been subdivided: letters and numbers correspond with those given in the main text.

Page numbers are given only for the preliminary sections, that is the Preface, General Introduction etc.